IMAGES
of America

LONE PINE

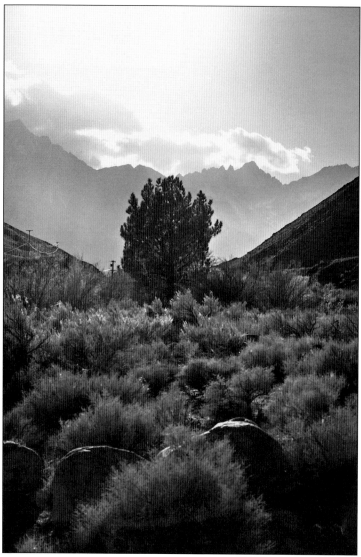

In the canyon beneath Mount Whitney, this tree's forbear once thrived and gave the town, the creek, and the peak their names back in 1860. The Hill Mining party was probably the first group of Europeans to stay any length of time, and the story is that they built their shelter near the first tree as they prospected the area. For many years, it was a landmark for travelers, but slowly the creek undermined the root system. The pine survived the giant earthquake of 1872 but came down in a windstorm in February 1882. When it was cut up, the rings established its age as 132 years. Now a new lone pine grows in the same canyon as a symbol of how this small town got its name. (Chris Langley collection.)

ON THE COVER: In a still from the film *Utah* (1945), Roy Rogers, "the King of the Cowboys," looks down from Trigger to speak to three beautiful girls; the nearest one—Dale Evans—was to become his wife. From left to right, "Queen of the West" Dale Evans, Beverly Lloyd, and "Princess of the Plains" Peggy Stewart are B Western royalty. They are out in the Alabama Hills, the location of scenes for nearly 400 films shot around Lone Pine, California. (Beverly and Jim Rogers Museum of Lone Pine Film History.)

IMAGES
of America

LONE PINE

Christopher Langley

ARCADIA
PUBLISHING

Published by Arcadia Publishing
Charleston SC, Chicago IL, Portsmouth NH, San Francisco CA

Printed in the United States of America

Library of Congress Catalog Card Number: 2007924211

For all general information contact Arcadia Publishing at:
Telephone 843-853-2070
Fax 843-853-0044
E-mail sales@arcadiapublishing.com
For customer service and orders:
Toll-Free 1-888-313-2665

Visit us on the Internet at www.arcadiapublishing.com

To my wife, Sandy, who shares my love of history, and taught me there is always a "Lone Pine connection."

CONTENTS

ACKNOWLEDGMENTS

I would like to thank the following people and museums: Beverly and Jim Rogers Museum of Lone Pine Film History, Bruce Branson collection, Lenis Munis collection, Joy Anderson collection, Eastern California Museum, Southern Inyo Museum, Laws Railroad Museum, Beth Porter, Southern Inyo Chapter of AARP, Lester Reid, Marlene Cierniak, Kathleen New, Sandy Langley, Mike and Nancy Prather, Lone Pine Chamber of Commerce, Inyo County Film Commission, www.owensvalleyhistory.com, Los Angeles Department of Water and Power, Mary Kemp, and Relles Amick.

SELECTED BIBLIOGRAPHY

Southern Inyo AARP. *Saga of Inyo*. Covina, CA: Taylor Publishing, 1977.

Chalfant, W. A. *The Story of Inyo*. Bishop, CA: Chalfant Press, 1975.

Cragen, Dorothy. *The Boys in the Sky-Blue Pants*. Fresno, CA: Pioneer Publishing Company, 1975.

Kahrl, William L. *Water and Power*. Berkeley: University of California Press, 1982.

Likes, Robert C., and Glenn R. Day. *From This Mountain: Cerro Gordo*. Bishop, CA: Chalfant Press, 1975.

Mulholland, Catherine. *William Mulholland: The Rise of Los Angeles*. Berkeley: University of California Press, 2000.

Smith, Genny Schumacher, ed. *Deepest Valley*. Los Altos, CA: William Kaufman, Inc., 1978.

Walton, John. *Western Times and Water Wars*. Berkeley: University of California Press, 1993.

INTRODUCTION

When the white traveler came into the Owens Valley in 1842, his eyes burned with the beauty of the landscape. The towering Sierra Nevada to the west stood guard, a snow-covered wall that cut the valley off from the rest of the California lands. To the east rose the Inyo Mountains, a name that Native Americans said meant "the dwelling place of the great spirit." Beyond these intimidating peaks, there lies the no-less-challenging desert and what later would gain the name Death Valley from the crossing in 1849 by W. L. Manly and others.

The area was geologically very active. Perhaps the travelers felt rumblings from the earth that presaged the great earthquake of 1872 that knocked down the nascent town of Lone Pine. Paiute and Shoshone Indian communities watched the strangers travel through the area, feeling curiosity mixed with discomfit that would turn to war, government ethnic cleansing, and the destruction of the natives who had inhabited the area for thousands of years. A terrible massacre of Native Americans at the shore of shimmering Owens Lake stands as a symbol of white attitudes at the time.

Explorers had come near or into the Owens Valley as early as the 1820s, with Jedediah S. Smith being credited by many authorities as the earliest. Capt. Joseph Ruddeford Walker entered the valley in 1833, guiding part of the Joseph B. Chiles Company, which had begun in Independence, Missouri. Author W. A. Chalfant reported that the journey was filled with infinite hardships. They traveled down the east side of the Owens River to the Owens Lake, where the livestock became so "jaded," according to author Chalfant, they abandoned the wagons, leaving behind sawmill equipment and supplies. The Native Americans were reportedly so terrorized, they fled. The only violence was an arrow shot that wounded night guard Milton Little.

It was in 1845 that the "Pathfinder," Charles C. Fremont, hired Walker and Richard Owens. It was Fremont who named the valley, the lake, and the river after Owens. Walker's name had already been given to the famous pass.

A report written by deputy U.S. surveyor A. W. Von Schmidt dated September 15, 1855, stated in part that it was "Land entirely worthless with few exceptions. . . . On a general average the country forming Owens Valley is worthless to the white man, both in soil and climate." Of the Native Americans, he wrote (according Thomas J. Henley, superintendent of Indians Affairs) "They are a fine looking race, straight and of good height, and appear to be active."

The prospectors had left the Comstock, Monoville, and Aurora areas looking for new claims. Cattlemen such as A. Van Fleet came to Lone Pine and probably built the first permanent building, a rough stone cabin, at about the same time that Charles Putnam was building his in Little Pine (later Independence.) This would be Putnam's Store, one flash point that would be involved in the Native American fighting soon to follow. A very hard year of weather from 1861 to 1862 caused more stockmen to stay in the Owens Valley for the good grazing lands.

During the 1861–1862 winter, it rained and snowed for more than 50 days straight, according to records from various parts of California. The winter weather created a famine among the Native Americans, who began to prey on white ranchers' cattle to survive. The period of 1861

through 1864 saw recurring fighting between the soldiers and settlers of the Owens Valley and the Native American tribes, cooling enthusiasm for mining by Mexican silver miners because of the danger of Native American attacks.

Pablo Flores and several Mexican partners had already discovered Cerro Gordo deposits before the outbreak of hostilities. With peace finally reestablished, he recorded the rich ore discoveries in 1865. Eventually competing claims would cause various mining concerns to fight it out in court. At the high point of activity in the early 1870s, there was approximately a murder a day recorded in the mining settlement 8,500 feet up at the base of Buena Vista Peak.

When they weren't fighting each other, the miners of the Lone Pine area were fighting the harsh and challenging physical conditions they encountered.

The wealth of the Cerro Gordo area was shipped as bars of bullion to the San Pedro harbor, kick-starting that port and the backwater town that became Los Angeles. The Los Angeles Department of Water and Power (LADWP) through the insights, imagination, and ruthless business sense of William Mulholland, John Lippincott, and Fred Eaton, began a contentious relationship between the Owens Valley residents and L.A. that resulted in violence at first but is fought out periodically in the courts now over water rights.

With the collapse of mining, Lone Pine had to discover other means of supporting itself, providing jobs, and allowing the citizens who chose to stay a means to make a living. The narrow-gauge Carson and Colorado Railroad gave way to the Southern Pacific. The roadways were improved with the start of the state highway system, and ranching has continued through the 19th century to this day. New employment was provided by the LADWP and the various federal agencies that took control of 98 percent of the land, including the Bureau of Land Management, National Forest Service, and the National Parks System. Schools, hospitals, and stores employ residents.

Tourism became more and more important, as hiking the Sierra Nevada (and conquering Mount Whitney), fishing, and hunting all gained popularity. Hollywood came on location to Lone Pine first in 1920. It brings significant revenue to the town because of the 400 feature films, countless commercials, and 100 television programs that have filmed locally. Filming continues today.

Lone Pine residents enjoy living in one of the most scenic and beautiful areas of the United States and the world, and today less than 2,000 call the area home. It is not always an easy life, as one local advised in the 1970s: "Honey, when you live in the Owens Valley, you learn to improvise, or you die."

This history explores, in pictures and text, this wonderful and unique place, which was, and remains, a land worth fighting for.

One

FIGHTING OVER THE LAND BEGINS

Genocide is a morally indefensible destruction of a people, and all across the American West, and in the East as well, it was the basic, if unspoken, policy of the federal government and many of the new residents. It was practiced or condoned by many settlers when they came into conflict with the original people who had lived there for thousands of years or more.

The Owens Valley became a land worth fighting for when Native Americans and white settlers came into conflict: the Native Americans to save their homeland and the settlers to make their new homeland safe and their land ownership claims unchallenged.

In the winter of 1862, starvation from very bad weather pushed the Paiutes to steal cattle for survival. Skirmishes led to fighting, but all the factors were in favor of the federal government, which brought in troops and established Fort Independence about 20 miles north of what would become Lone Pine.

Early explorers, such as Capt. Joe Walker, Richards Owens, and probably Jedediah Smith, had ventured through the new lands. John C. Fremont had named many places for Owens.

Paiute and Shoshone residents had been living there thousands of years already and had family groups living in many areas. They survived by gathering pine nuts, hunting small animals, and fishing. It was not an easy life, but it was a satisfactory one. It made the local Native American people above average both morally and physically compared to other California tribes, according to Quis, the pseudonym of an anonymous *Los Angeles Star* reporter accompanying the Capt. J. W. Hutchinson expedition of 1859.

In an article in the August 27, 1859, *Los Angeles Star*, the correspondent reported that he observed "myriads of small flies over the water. The winds drive the larvae in large quantities upon the shore of the lake, where they are easily collected by the squaws.

"The Wakopee or Owens River Indians appear to be both morally and physically superior to any of their race in California, for in point of probity and honesty I certainly have never met their equal," he continued. "Whilst talking to their headmen, who had assembled for that purpose, Captain Davidson informed them that so long as they were peaceful and honest, the government would protect them in the enjoyment of their rights."

9

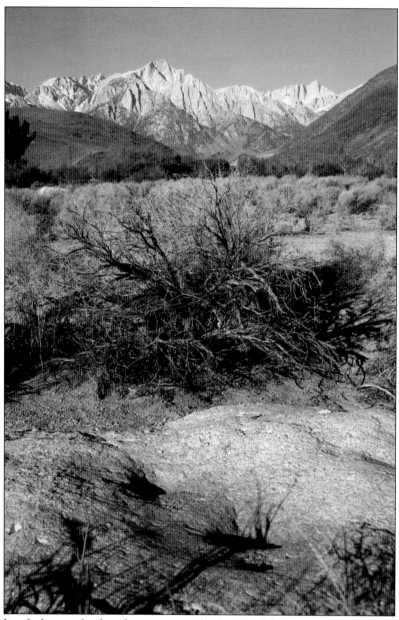

Two grinding holes can be found in granite a few hundred feet west of houses in Lone Pine, demonstrating the presence of Paiute and Shoshone inhabitants in prehistory. When European explorers first came in numbers in the 1860s, it was estimated there were 1,000 Native Americans living in the valley and in nearby areas. When exactly the Paiute and Shoshone people moved into the area probably can be measured in hundreds or a few thousand years. The many petroglyphs found in the area predate these people. There are artifacts that date back to the Pinto people, named because similar artifacts were first found in the Pinto Basin near Riverside. Aboriginal peoples would have lived here 4,000–5,000 years ago, and archeological evidence indicates first occupation may have been 10,000 years ago. These grinding stones are in Lone Pine Canyon. The Alabama Hills are in the mid-background, and the snow-covered Sierra Nevada peaks of Mount Whitney and Lone Pine are in the far background. (Chris Langley collection.)

A few examples of petroglyphs (or figures scratched into rock) are found in the area of Swansea on bluffs overlooking the lake. Imagine sitting to make the pictures or grinding acorns as the waves of the lake lap against the rocky shore. The target shape with concentric circles on the right is a solstice calendar that marks the longest day with a pinpoint of light. It had been severely vandalized by 2005. (Chris Langley collection.)

Unique to the diet of the Paiute Indians of the Lone Pine area was the Owens Lake brine fly pupae that they could harvest with sieve-like baskets. The taste is reported as "slightly salty" by Mike Prather, an Owens Lake authority. Here the flies swarm at the edge of an area of water on the dry lake, the target of an anti-dust Los Angeles mitigation project. The diet of the Native Americans included acorns, pandora moth in the pines, rabbits, and birds, among other things. (Chris Langley collection.)

Although a heavily alkaline lake, Owens Lake was full of water, and many birds and animals gathered in areas where streams coming from the mountains emptied into the water. Paiute hunters set up hunting blinds where they waited for prey. These carefully assembled rocks are near Cottonwood Creek, where a Native American campground is said to have been. (Chris Langley collection.)

A grinding hole with a beautiful view not far from a hunting blind gives mute witness to an area inhabited by Paiute families. Conflicts between stockmen escalated in the winter of 1861–1862, one of the hardest winters in recent times, because cattle were available for predation by starving Native Americans. (Chris Langley collection.)

A local photographer captured the image of a Paiute mother and child on a traditional cradle board early in the 19th century. The culture was under attack already: children, removed to boarding schools out of the area, were beaten for using their native language. (Lenis Munis collection.)

A large group of Native American baskets is on display in this private collection in Bishop in 1912. Several of this set still exist. The Eastern California Museum in Independence has a world-class collection on display in the main exhibit area. (Lenis Munis collection.)

John C. Fremont is an explorer's name frequently mentioned with the official European discovery of the Owens Valley. He never set foot here, but Joseph Ruddebeck Walker, directed to do so by Fremont as part of his third expedition, did. There is evidence that Jedediah Smith may have come through, leaving an inscription dated 1826 at Little Lake, which was destroyed soon after he reported the discovery. (Walker Book.)

In 1843, Walker was part of the Chiles expedition. Then, in 1845, he was part of the third Fremont exhibition, which split at Walker Lake; Fremont and Owens, among others, went north. Walker and Edward M. Kern (namesake of Kern County) and the main group went south, over the pass that bears Walker's name. Fremont gave Owens's name to the area, even though his new friend never set foot there. (Joselyn Art Museum.)

14

While a peace treaty (seen here in a facsimile developed by the *Inyo Register* later) was signed between warring parties in January 1862, fighting erupted in several places to the north of Lone Pine. A stand at Putnam's store in Independence (Little Pine) ended with four Native Americans dead. In April, there was the Battle of Bishop Creek when 50 settlers were greatly outnumbered by Paiute fighters defending their homelands. Soon the Native Americans were in control of the valley as the settlers retreated south until troops began to arrive from Camp Latham (Santa Monica) and Fort Churchill (Nevada).

WE. THE UNDERSIGNED, citizens of Owens Valley. with Indian chiefs representing the different tribes and rancherias of said valley, having met together at the San Francis Ranch, and after talking over all past grievances and disturbances that have transpired between the Indians and whites, have agreed to let what has past be buried in oblivion; and as an evidence of all things that have transpired having been amicably settled between both Indians and whites, each one of the chiefs and whites present have voluntarily signed their names to this instrument of writing.

And it is further agreed that the Indians are not to be molested in their daily avocations by which they gain an honest living.

And it is further agreed upon the part of the Indians that they are not to molest the property of the whites, nor to drive off or kill cattle that are running in the valley, and for both parties to live in peace and strive to promote amicably the general interests of both whites and Indians.

Given under our hand at San Francis Ranch this 31st day of January, A. D. 1862.

<div align="center">

His
GEORGE, X CHIEF,
Mark.
His
DICK, X CHIEF,
Mark.
His
JIM, X LITTLE CAPTAIN.
Mark.

</div>

Signed on the part of the whites by SAMUEL A. BISHOP, L. J. CRALLEY, A VAN FLEET, S E. GRAVES, W. A. GREENLEY, T. EVERLETT, JOHN WELCH, J. S. HOWELL, DANIEL WYSEMAN, A. THOMPSON, E. P. ROBINSON.

In March 1863, a massacre occurred near the land spit that had been formed; many Native Americans, some old, women, and children, ran into the lake hoping to escape. To avoid drowning, they returned to shore, where they were shot as they emerged from the water. The number of victims has been reported as anywhere from 16 to 39, with the white settlers trying to minimize their actions.

Camp Independence on Oak Creek near the town site was established with 157 soldiers brought to the area by Col. George C. Evans from Fort Latham, between L.A. and Santa Monica. The fort at Camp Independence was abandoned in the summer of 1863, when Native American hostilities appeared to have ended. Settlers were very unhappy about closing this fort and campaigned, perhaps exaggerating the "Indian problem" by word of mouth; the fort was reestablished two years later and remained until 1877. (Eastern California Museum.)

A poster advertising for "Indian Fighters" was authorized by the governor. Fighters would get 40¢ per day and all the horses and plunder taken from Native Americans (they needed to have their own horses, however). This advertisement was dated August 13, 1864, and the government wanted 100 men a day. (www.iwchildren.org/calif.htm.)

The Native Americans (numbering 400) surrendered at Fort Independence believing they were to have a great feast celebrating peace. Instead they were held and forced the next day to begin traveling to Fort Tejon in what amounted to an ethic cleansing of the area of native populations. Suffering greatly, many were able to escape and travel back to their homeland, where they were left destitute and homeless. (Eastern California Museum.)

The Native Americans who were able to return to the Owens Valley were, on occasion, hired to work on hay ranches and with white cowboys on the lands being settled by the stockmen. The original Paiute residents were not citizens of California or the United States and ended up stripped of their lands and ways to make a life above sheer poverty for the next few decades. (Eastern California Museum.)

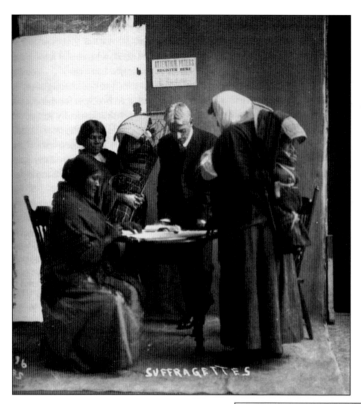

Photographer Andrew A. Forbes from Bishop focused his camera on many Native American faces, and a wonderful collection of Paiute baby pictures exists at the Eastern California Museum in Independence. In this 1916 image, he captures Paiute women, mostly reduced to working as laundresses and domestic help for white settlers, being registered to vote in Bishop. Women gained the vote in 1920. (Eastern California Museum.)

Forbes's picture of Joe Bowers, an elder from the Paiute tribe, shows the painful lessons that living in the Owens Valley taught the original inhabitants in the years after the fighting ended. To revenge the killing of some white settlers (Mrs. McGuire and her son at Haiwee Meadows) by Native Americans, Hank Hunter stated, "the soldier rode into the camp of Indians opened fire . . . those who were not killed attempted to run, but were shot down like animals." (Eastern California Museum.)

Two

Conflict over the Earth's Riches

Pablo Flores slowly climbed the sharp incline leading to what would be the greatest silver find in California. He and several companions had come in from Mexico with the Mexican mining traditions and skills. Just when they began to realize what they had discovered, the Paiutes began their disastrous but inevitable war with the settlers and then the soldiers at the newly established Fort Independence.

When work could continue with some sense of security, Flores registered his discovery. At first it was simply surface mining, with the prospectors processing their ore in rudimentary adobe and stone ovens called *vasos*. These inefficient methods still worked because at first the ore was so rich.

The area was known as Cerro Gordo, or "fat hill," which was one of the many Spanish names given to different areas and mining discoveries up at 8,500 feet on Buena Vista Peak. The nearest town in the valley after Keeler was Lone Pine, which benefited early in its history from the various mineral discoveries. Victor Beaudry, a French Canadian and former forty-niner, opened a store up at the new settlement. A payment for overdue accounts at his store gave him significant interests in the Union and San Lucas Mines.

Mortimer Belshaw arrived from San Francisco and immediately set about building his own smelter and gained part of the Union Mine. Belshaw and Beaudry became partners, each bringing smelters and claims to the syndicate.

Beaudry cut a toll road to the mines from Keeler called the Yellow Grade Road. The year 1868 was a time of transition for Cerro Gordo, and Belshaw and Beaudry had soon hired Remi Nadeau to run a freighting company to transport the bullion, eventually to San Pedro, Los Angeles's new port. For the next seven years, everything was profit and prosperity for the men.

At its peak, Cerro Gordo was a rollicking and deadly town of much activity. When the various owners weren't fighting in court, the miners were fighting in the streets.

Other claims were also being recorded. Panamint, Darwin, Coso, Reward, and other mining camps came and then went, leaving behind the town of Lone Pine, establishing the town as a small and permanent center of commerce.

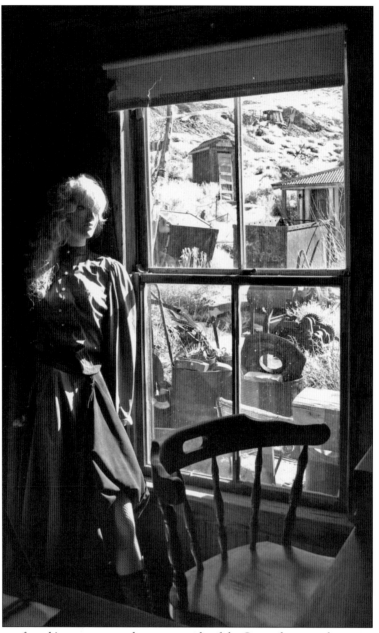

The discovery of earth's treasures on the eastern side of the Sierra drove settlement, conflict, and greed. It made a few people rich and many people older. After the Native American populations had been subjugated and stripped of their traditional lands, mines boomed and subsided in the rich areas around Lone Pine. Life was difficult for the miners living in their tents in a harsh climate, but the rewards were seductive on the slopes of Buena Vista Peak. A mannequin dressed in historically appropriate garb looks with dead eyes out on the ruins of Cerro Gordo today, where at one time, 10,000 workers both in the shafts and on their backs danced to the siren call of bullion. Mining towns came and went in the Owens Valley—Bend City, San Carlos, Kearsage, and Chrysopolis, just to name a few. Cerro Gordo was the greatest of all, producing $17 million in its heyday. (Chris Langley collection.)

A prospector's life was clearly a difficult one. Tent shelters were poorly matched against the heat of the summer and the dry cold of the winter nights. Food was in short supply and rudimentary, water remained an issue, and the work itself was backbreaking and endless. Success often brought human scavengers likely as not to kill you to take your claim and ore. (Eastern California Museum.)

The first claim on what would be called Cerro Gordo came in 1865, and within a few years, more than 700 claims were filed. This cabin belonged to William Hunter, who came to the mines soon after the end of the Civil War and bought the Belmont Mine. He founded the Hunter ranching family of Olancha. (Eastern California Museum.)

Cerro Gordo, like so many other boomtowns, exploded on the scene. The town spread out in the saddle of the mountain at about 8,300 feet. Here it is seen some time between 1871 and 1879. Victor Beaudry was a merchant who visited friends at Fort Independence and soon opened a store at Cerro Gordo, gaining control of mines through overdue accounts. (Eastern California Museum.)

By 1879, the boom years of the mining area were over, but they would return again between 1911 and 1915, when zinc deposits were located. Activity dropped to almost nothing by 1900, but zinc discovery led to increased mining in 1911 for four or five years. (Eastern California Museum.)

Three gentlemen had an impact on Cerro Gordo mining. First is Mortimer Belshaw (above, left) who fought for control of the various areas in court and partnered with Victor Beaudry. Increased costs, particularly legal, ended the boom time in under a decade. Remi Nadeau (above, right) ran the freighting company that shipped the bullion from Swansea to San Pedro in about 22 days. The trip around the lake was ended when Sherman Stevens built the *Bessie Brady* to bring the bullion across the lake to Cartago. In the years after the boom times, the 1880s and 1890s, mining was difficult and profits rare. Thomas Boland (right) ran the Union Mine during this most difficult time. (All images Eastern California Museum.)

Access to the town was difficult coming up the Yellow Grade Road, which had been built in 1868 by Belshaw as a toll road. Here supplies are unloaded from a pack train for the American Hotel, a two-story edifice completed in 1871 and still available for accommodations as of this writing.

Besides food and supplies for the young "wide open town," (meaning there was no law enforcement) charcoal had to be brought in for the furnaces. Since the wood supply was quickly exhausted, Sherman Stevens constructed a sawmill in the Sierra Nevada above Cottonwood Creek. The wood was carried down a 13-mile wooden flume to the charcoal kilns, which are preserved near Highway 395.

Julius M. Keeler arrived on the scene in 1879, working as an agent for D. N. Hawley. Quickly, Keeler laid out the town that now bears his name (briefly it was Hawley), revived businesses, and worked for the Owens Lake Mineral and Mining Company. He used a new ship, the *Mollie Stevens*, to ship lumber across the lake. The town grew, and soon a hotel was built there. (Bruce Branson collection.)

Getting the Cerro Gordo bullion to Los Angeles was a challenge, and Remi Nadeau's mule teams transported 18 tons of silver across the desert each day beginning in 1869. He fulfilled his contractual obligations with the mine for five years before returning to Los Angeles and running a freighting system there. (Eastern California Museum.)

Questions about their structure and history surround the two steamships, the *Bessie Brady* (1872–1879) and the *Mollie Stevens* (1877), even though their histories were short. Legend persists that a lost barge towed by one of these ships or a shipment of bullion lies in the muck at the bottom of the lake, lost during a storm. The dock for the *Bessie Brady*, under construction, ended up 150 feet short when the great earthquake tilted the lakebed permanently toward the southeast. (Eastern California Museum.)

Because of the challenges of shipping bullion bars safely and the rate of production in the boom years, walls of bullion sometimes accumulated up at Cerro Gordo and down at Swansea. Storytellers recount that even shelters were temporarily built of walls of bullion. (Eastern California Museum.)

It is rare to be a captain of a steamship in the middle of the desert, but Casper Titchworth, captain of the *Bessie Brady, c.* 1879, was exactly that. (Eastern California Museum.)

Col. Sherman Stevens was an entrepreneur who created a lumber company, built a sawmill in the Sierra Nevada, built charcoal kilns, and constructed a second Owens Lake steamship, the *Mollie Stevens*, named for his daughter. He had great financial success until the Cerro Gordo, Darwin, and Coso boom times ended. He died in Lone Pine in 1887. (Eastern California Museum.)

Julius M. Keeler worked to revive businesses after the boom years and established the town of Keeler, easily found on Highway 136 at the foot of Cerro Gordo Road. (Eastern California Museum.)

The only road into Cerro Gordo, the Yellow Grade Road (so named because of the earth it went through), was a rugged 8-mile challenge. In this undated image, 17-year-old Ollie Dearborn navigates the road. Today the county maintains the road to Cerro Gordo, but four-wheel drive is recommended, and it is subject to weather closures during the winter. (Eastern California Museum.)

The smelter at the bottom of the Yellow Grade (Cerro Gordo) Road is still there today. (Eastern California Museum.)

After the resurgence of zinc mining in the years from 1915 to 1920, mining did continue, although at a lower production rate. Here are miners on ore cars as they come out into the daylight from the Estelle tunnel. (Bruce Branson collection.)

Somewhat earlier in the century, miners wait outside the Wells Fargo offices to collect their paychecks in Keeler for the Cerro Gordo mines. The town's fortunes depended on the fortunes of mining in the area, and the town boasted saloons and other amenities to please the tastes of the men after a long day of work. The white building behind the Wells Fargo offices is a saloon. (Bruce Branson collection.)

Mining depended on many things, including an economical and safe way to transport the bullion to market; hence the Carson and Colorado narrow gauge was developed to serve the mines in eastern California and Nevada. When the railroad was announced, local farmers were opposed, but the line reached Benton in January 1883 nonetheless. By July, it reached Keeler. It was planned to go on to Mojave, but the economic climate made that impossible, so Keeler became the end of the line. W. A. Chalfant, historian and publisher of the *Inyo Independent*, gave it the nickname "the Slim Princess." In March 1900, the line was sold to the Southern Pacific. By 1932, passenger service had been discontinued, and on April 30, 1960, the Slim Princess made its last run. An engine from the system is now part of the Eastern California Museum collection and is on display at Dehy Park in Independence. Here Engine No. 18 crosses the Owens River Bridge on its way to Keeler under a full head of steam. (Eastern California Museum.)

For the residents of towns like Darwin, life for the people involved in mining was exciting and difficult, and the community remained optimistic during the prosperous times. But during the bad times, life was very hard, and the residents were attuned to disappointment. They wrestled with the question of whether to travel to rumored new deposits or simply stay put. This image depicts a lighter moment, as some of the early residents and children gather for a small event. (Southern Inyo Museum.)

The irreverent saying goes, "The miners came in forty-nine, the whores in fifty-one, and when they got together, they made the native son." First came the miners, and then the families and schools—however rudimentary—came soon after. The Darwin Elementary School was a simple shack, but the faces on the youth show a combination of expectation and mischief. (Southern Inyo Museum.)

When the mines were operating in the areas near the town, Lone Pine grew in response to the influx of cash. Ranchers raised cattle, farmers grew food, and merchants provided the supplies needed. The town was a place to go to relax, for recreation, and to relieve the stress of hard work and boredom. The men had a choice of saloons, such as the Reynolds Saloon, pictured c. 1899. (Eastern California Museum.)

In Olancha, the brown adobe housed the post office run by William Walker from 1870 to 1891. The ranch had originally been deeded to Sheriff Tom Passmore in 1874 in a document signed by Pres. Ulysses S. Grant. (Lenis Munis collection.)

Besides the underground mining operations, there was also the Saline Valley Salt works, which began here in 1913. The salt here was reputed to be one of the purest deposits anywhere in the world. It was scraped and piled to dry completely, and a salt tram ended at an area near Swansea, where the salt was processed, bagged, and sold. Some foundations remain near Swansea, marking the mill building locations. (Bruce Branson collection.)

The terminus of the salt tramway can still be found today along with a few towers up on the mountains above Highway 395. Some of the men apparently did not enjoy going to work, for they would ride the tram back to Saline Valley high over the rocky cliffs, swinging in the wind. (Bruce Branson collection.)

Dr. Darwin French, pictured, discovered the Coso mining area in March 1860. Legend has it that a young Mississippian in one of the parties crossing Death Valley in 1849 picked up a piece of pure silver between Stovepipe Wells and Emigrant Ranger Station to replace his gun sight. French was searching for the so-called "Gunsight Mine" when he discovered Coso, which grew to be a small town. It is now part of the Naval Air Weapons Center–China Lake. (Southern Inyo Museum.)

While many mines in the Inyos, Coso, and Death Valley contributed to the Lone Pine story and its start as a community, of interest is the Reward Mine, which has a tunnel that can actually be entered in a car and driven for over a mile. The Reward Consolidated Mining Company worked the Eclipse Mine (now called Reward) from 1888 to 1914. (Southern Inyo Museum.)

Three

A TOWN TAKES SHAPE

While many of the towns associated with mining discoveries, such as Bend City, Chrysopolis, and San Carlos, appeared over night and were gone when the minerals petered out, Lone Pine had staying power. The first center of commerce there was the Meysan Store, opened in 1869.

There were about 100 people living in Lone Pine in simple adobe dwellings in 1872. Tragically one fourth of them were killed on the night of March 26, 1872, at 2:30 in the morning. The great earthquake of 1872, called El Tremblor, hit with such force that the courthouse in Independence was destroyed, as were almost all the houses and barns in Lone Pine. Twenty-nine people died in Lone Pine. The wall of the Meysan store can still be seen in Lone Pine in the alley behind La Florista.

The pioneer spirit was strong though, and the remaining residents immediately began to rebuild. In 1874, the biggest Independence Day celebration yet in the Owens Valley was held in Lone Pine. Dorothy Cragen, in her book *The Boys in Sky-Blue Pants* reported, "No less than six nationalities were represented in the grand parade, each group carrying its national flag. A brass band was imported from Los Angeles to give the keynote to the day and to show how grown up Lone Pine had become."

The first attempts to organize a county, to be called Coso, came in February 1864. Mono County had been formed in 1861; Inyo County remained to be carved out from Tulare and surrounding counties. Various names and county seats were tried and failed. Two years later, Inyo County became a reality with Assemblyman J. E. Goodall's introduction of legislation on February 17, 1866. Independence was to be the county seat.

The railroad came down from the north in the form of a narrow-gauge line ending at Keeler. The Slim Princess, as the Carson and Colorado line was called by locals, eventually was joined by the Southern Pacific broad gauge, meeting for transfer of cargo at Owenyo just north and east of Lone Pine. Schools, roads, and other town services developed.

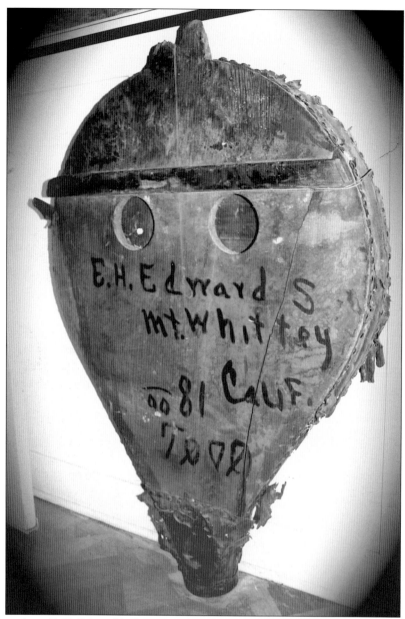

The bellows from E. H. Edwards's Store stand in the display case of the Southern Inyo Museum in Lone Pine as a reminder of the beginnings of the town as an equine, mining, and ranching center. Edwards's Store was on the north side of town, near the plaza, which also was bordered by Edwards's ranch. The first store appears to have been the Meysan Store in the center of town. The adobe wall, which marks the back wall, can still be found in the back alley behind La Florista. The town had just really gotten started when it was almost completely flattened in the great earthquake of March 26, 1872. The lessons of building using adobe brick were easily learned, and the town set about quickly reinventing itself. The bellows was used in blacksmith work. When the automobile began to replace the horse, tourism as an economic enterprise became possible. Lone Pine had finally found something to replace the unpredictable industry of mining. (Southern Inyo Museum.)

The Lone Pine Plaza was located on the north end of town near the Edwards Ranch. It was the focus of outdoor town celebrations and ceremonies such as the Fourth of July. Here the flag that was raised to announce the beginning of the event flies proudly over the plaza, c. 1906. (Lone Pine AARP.)

Ranching families were often extended and played an important part in Lone Pine's early history. One of large ranching families with an important ranch was the Lubken family. Here, on the ranch, assorted Lubken and neighbor children pose for the camera in front of Mount Whitney and the Sierra Nevada. Judge Lubken was an important official in the county government, and two roads bear the family's name today. (Bruce Branson collection.)

Two hundred miles from Los Angeles, over dirt roads, the first settlers of the Owens Valley had few stores to use. Supplies would be freighted in, and far-flung shoppers would have to come into to town. Traveling salesmen would sometimes bring the store to the homesites in wagons, however. Here two salesmen pose by their wagon full of goods on their way to a ranch before the 1900. (Bruce Branson collection.)

On March 26, 1872, at 2:30 a.m., a major earthquake hit the Owens Valley, with its center in or near Lone Pine. Most estimates now put it over 8.2 and some as high as 8.6 on the Richter Scale. In places, the ground was displaced more than 15 feet, and from the evidence it was another in a series that had shaken the valley in recent geologic times. (Chris Langley collection.)

Estimates differ, but it appears at least 29 people died in the quake. John McCall wrote, "My wife and little daughter, as well as myself, were buried in the ruins for an hour and a half; there were four feet of adobe on us. We were living a mile and a half from anyone, and were nearly dead when taken out . . . everything lost." This picture shows the courthouse destroyed. (Bruce Branson collection.)

Charles Begole's barn was in ruins after the quake, showing that wooden structures did not fare well either. On Owens Lake, a wave was created that swept water away and then back toward Swansea, and 200 feet beyond the previous edge of the lake. It then receded again because the lake had been tilted south. Diaz Lake grew from a swamp to a body of water because springs appeared along the fissure, which can still be seen just west of town. (Bruce Branson collection.)

The miners are gathered around the stove at the Darwin Saloon in this undated image. Saloons served as community centers for the men, but no "decent" women were ever inside. (Lone Pine AARP.)

This image of Lone Pine, c. 1882, shows what was on the corner now occupied by Josephs Market, including (1) Zaun Ice House; (2) wagon shed; (3) blacksmith's shop; (4) R. C. Spear house; and (5) A. C. Harvey house. (Lone Pine AARP, adapted from Eastern California Museum.)

Meysan was an important early family to Lone Pine because Charles Meysan bought property on Main Street from Anna Heppner. He paid $600 for the adobe structure on December 18, 1869. The family was attracted to the area because of the news of Cerro Gordo. Sadly the store was destroyed in the earthquake, and Charles's 11-year-old daughter, Alice, was killed. The store was the first structure rebuilt with lumber hauled by Remi Nadeau. (Beverly and Jim Rogers Museum of Lone Pine Film History.)

Charles Meysan's son, Felix, continued the family's success in town. In 1905, his family consisted of wife Ellen holding Charles, with Elodie on the right and Zelia on the left. Felix enjoyed the outdoors. He dreamed of the lake that bears his name being stocked with trout. He served as secretary of the Lone Pine Water Company from 1902 to 1934. Charles had raised his family to enjoy music, and Felix played in the community band as well. (Eastern California Museum.)

E. H. Edwards's Store is seen here in a very early picture. The bellows remain from the store, a gift of the Aigner family to the Southern Inyo Museum, which was once the Darwin Museum, located in that area. (Eastern California Museum.)

This early picture of Lone Pine shows the town buried under significant snowfall. George Brown Sr. maintained that when the Owens Lake had water in it, a mini-climate was created, and snowfalls were increased through a "lake effect." (Eastern California Museum.)

Schools were organized in the 1870s but quickly proved inadequate for the growing population. The first schoolhouse in town was located near what today is the location of the Statham Town Hall. Other schoolhouses were built in more rural areas, such as George's Creek, to serve the ranch populations. (Eastern California Museum.)

Many of the early workers in the mines and ranches were from Mexico. Around 1900, many residents were Mexican, and the southern part of the settlement had many vineyards. Mary Austin referred to the town as "The Little Town of Grape Vines" or *El Pueblo de Las Uvas*. Here Mexican cowboys pose after roping a calf. The Alabama Hills and the Sierra Nevada are in the background. (Bruce Branson collection.)

1810. 1884.

MEXICAN NATIONAL HOLIDAY!

——SEPTEMBER 16, 17, 18.——

At Lone Pine, Inyo County, Cal.

——o——

PROGRAMME:

At 11:30 P. M. of the 15th the National Flag will be raised with appropriate remarks by

S. B. PADILLO,

followed by **SALUTES**, and with

Music by the Band.

——o——

Following this will be a song entitled *THE HIDALGO' MARCH*, by local talent.

At Sunrise on the 16th a National Salute will be fired. The literary exercises will commence at **10 A. M.** and will consist of the following:

Reading of the Declaration of Independence.

Oration, and remarks by Enrique Lopez and other persons.

The National Air will be rendered by local talent.

At sunset a National Salute will be fired.

On the evening of the 16th there will be a

-:-:-Grand Display of Fire Works!-:-:-

——o——

At 8 o'clock P. M. *Sharp*, there will be given

A DANCE

——AT——

RICHARDS & CASTRO'S HALL.

Admission Free.

Supper at the - - - Lone Pine Hotel.

Tickets (Admitting Lady and Gent) $2.00.

On the 17th there will be various amusements, especially

——Foot Racing.——

All persons are cordially invited to be present on the above occasion, as a good time will be guaranteed and perfect order insured.

By order of the Committee,

FRANK MIRANDA,	President,
M. CASTRO,	Secretary,
BELLES CARRASCO,	Treasurer,
RUPERTO CARRASCO,	Collector.

☞ J. G. Dodge will carry passengers to and from the Lone Pine Depot at reduced rates.

When reading about the life of the town, what is striking about the waning years of the 19th century through the Depression is that the town made its own fun. People in those days worked hard, but also worked at creating fun events for entertainment. This advertisement for the Mexican National Holiday to be celebrated September 1884 included three days of music, dancing, and fireworks. Chautauquas, rodeos, visiting actors, lectures, and traveling movie projectionists were just some of the things to look forward to in the community. Many of the Fourth of July celebrations were large and often included competitions among the miners. Of course there were regular rodeos and cowboy competitions. Lone Pine's ethnic mix in those days before 1900 was Mexican, Native American, and European. (Eastern California Museum.)

Two views of early Lone Pine feature rain, puddles, and mud. Winters were cold and windy and swung from too much rain to too little rain. Summers were hot, dusty, and windy. The Owens Lake produced dust off the southeast quadrant long before it was emptied by the Los Angeles Department of Water and Power; the draining of the lake made it much worse. The ending of great mining prosperity meant Lone Pine's economic health weakened significantly as well. (Both images Bruce Branson collection.)

Reuben Cook Spear came to Lone Pine at the age of 22 in 1874. He was involved in many projects and business plans, including mining for gold in the Alabamas and a blacksmith shop on corner where Josephs is now. The Spear family house, near Lone Pine Creek, was located just behind the present location of Josephs Market. (Lone Pine AARP.)

The Joseph Skinner family settled in Lone Pine in 1882, and Joseph and his son, Max, drove teams, first delivering wood to the Darwin furnaces and then transporting freight. Max Skinner was one of the last mule skinners, having driven 20 mule teams. He later went into business with Silas Reynolds with stores in Lone Pine and Darwin. (Lone Pine AARP.)

Four

GRABBING WATER TO GROW A CITY

Lone Pine had several attributes on which to base the economy of the area. It had minerals from the earth, water from the Sierra, with the streams flowing into Owens River and Owens Lake, and beautiful natural land for fishing, hunting, hiking, and filming. The town fathers and local entrepreneurs have used all these methods to keep the little town fighting for its existence.

A major force in establishing Lone Pine was the City of Los Angeles. If Cerro Gordo bullion was a major factor in starting the city, then the water from the area was a major factor in growing L.A. to the giant metropolis it is today. The relationship was usually one sided, first with all the riches going south, and then with all the water following through the engineering feat of the 200-mile Los Angeles Aqueduct to the San Fernando Valley.

As with any relationship, there have been periods of peace and mutual advantage, but it is a stormy marriage, and often anger and even violence has forced the two combatants to law enforcement and the mediation of the courts. So it remains today, as the people of the valley have relied on the courts to force the LADWP to fulfill its promise of putting water back in the Lower Owens River. Mitigation of the dust and environmental harm of taking the water out of Owens Lake has run to almost half a billion dollars and is still going on.

The dream of William Mulholland, Fred Eaton, and J. P. Lippincott was not all bad for Lone Pine and the Owens Valley. The building of the aqueduct forced the building of the railroad, the upgrading of the roads, the creation of infrastructure, and the bringing of electricity to Lone Pine relatively early.

However, comparing the land around Lone Pine before the aqueduct and after points out just how devastating the effects have been.

The water issues, more than any other thing, define what Lone Pine is and isn't today. Local feelings are summed up in a local saying: "Flush your toilet, L.A. needs the water."

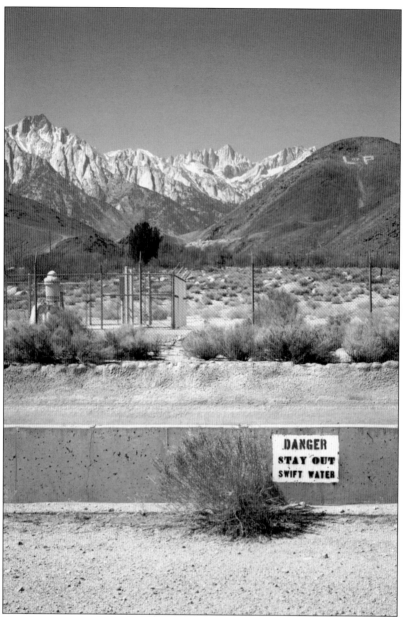

Western films focus many of their plots on the bad guys attempting to control land and water. Control the land, and you control the water. The history of the West is all about land and water. It has been no different in the Owens Valley and Lone Pine. In the county, which is a size comparable to Vermont, less than two percent of land is privately owned. The Bureau of Land Management (BLM), United States Forest Service (USFS), National Park System (NPS), and the Los Angeles Department of Water and Power (LADWP) are four of the largest municipal landholders in the area. The LADWP bought land, relying on secrecy and the greed of local residents to gain control of the water of the area and then bring it to the young city. This picture shows the Los Angeles Aqueduct channel right outside Lone Pine, a water pump, the Alabama Hills with the LP initials, and the snow-covered Sierra Nevada and Mount Whitney. In Lone Pine, it is all about water. (Chris Langley collection.)

Farming and agriculture were a major business before the water went south to build Los Angles. Here are alfalfa fields in the northern part of valley, where water was plentiful historically. The number of farms grew from 242 to 424 in the years between 1880 and 1900. As water began to disappear, agricultural growth stopped, and the number of farms went from 521 in 1920 to 482 five years later. (Lenis Munis collection.)

Native Americans and Mexicans began to be employed by farms as the mines closed, and the displaced original residents abandoned the traditional ways of life. Bags of grain, having been harvested from the farms of the area, await shipment. (Lenis Munis collection.)

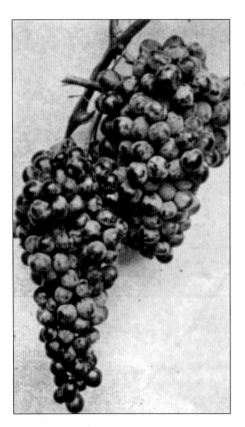

Lone Pine had many grape arbors, particularly on the south side of town, which were planted and tended by the original Mexican settlers who had been attracted to the area by mining prospects. Today some of the original grape vines can still be found in that area. (Lenis Munis collection.)

Before the city of Los Angeles took the water, Lone Pine had many farms. This farm was located in the area before 1914 and was used to illustrate Inyo's developing agriculture. (Lenis Munis collection.)

Three men came together in history to radically change the future for Lone Pine. In a rare photograph of these three (they really didn't want to be seen together because their plan required great secrecy to succeed) are, from left to right, J. P. Lippincott, an officer of the Reclamation Service and consulting engineer for Los Angeles; Fred Eaton, Los Angeles mayor and former water superintendent; and William Mulholland, engineer and water superintendent for the city. (Los Angeles Department of Water and Power.)

Mary Hunter married Stafford Wallace Austin, registrar of federal lands in Independence. S. W. Austin wrote letters to the General Land Office in June 1905 complaining of Fred Eaton's activities in the valley, forcing Lippincott to distance himself from Eaton. Mary Austin went on to become a noted author and early feminist who championed the endangered local environment against the city. (Eastern California Museum.)

The prize sought by Los Angeles was the water flowing from the Sierra Nevada into the valley, here symbolized by a rushing Cottonwood Creek. J. C. Clausen of the U.S. Reclamation Project developed a federal irrigation project in 1903. By 1904, Los Angeles realized it was facing a devastating water shortage, and Eaton made plans to get control of Owens Valley water. (Los Angeles Department Water and Power.)

By 1905, Eaton had convinced William Mulholland of the water in the Owens Valley, and Mulholland envisioned building an aqueduct to bring the water to the city. It would take a monumental effort and brilliant engineering, but it was feasible. Money was appropriated, and Eaton began buying land and secretly conveying it to city ownership. (Los Angeles Department Water and Power.)

In 1906, Lippincott left the Reclamation Service and took a leading post with the Los Angeles Aqueduct Project. In 1907, the service abandoned the federal irrigation project, and L.A. voted for $25 million to fund the building of the aqueduct, shown under construction in the Alabama Hills. (Los Angeles Department Water and Power.)

It was in July 1905 that the story first broke in the *Los Angeles Times,* and the people of the Owens Valley realized they had been duped by the city. Great anger spread through the residents and thus began a continuing conflict over the welfare of the area and the power to fill the water needs of a growing metropolis. Forms were in place to pour concrete to line the aqueduct outside of Lone Pine. (Los Angeles Department Water and Power.)

The Los Angles Aqueduct channel, or conduit, winds like a giant snake about 200 feet above Owens Lake, full of water that would be drained in the next 20 years. Los Angeles had captured the Owens River at the intake to the north, near Aberdeen, and the water no longer entered the lake at the delta just southeast of Lone Pine. (Los Angeles Department Water and Power.)

The concrete-lined canal continued its serpent slither south, shown near Little Lake. Many different geological and surface challenges faced Mulholland in the building of the aqueduct, which finally measured 232.7 miles from the intake to the lower end of the last tunnel above the San Fernando Reservoir. In this picture, the canal is covered with a concrete lid. (Los Angeles Department Water and Power.)

Along with the building of the canal, conduit, and siphons, the project included five hydroelectric plants: Division Creek (800 horsepower), Cottonwood Creek (8,000 horsepower), Haiwee (61,500 horsepower), San Francisquito (47,650 horsepower), and San Fernando (9,685 horsepower). This led to earlier electrification for severely rural towns than would otherwise have been possible. Here the Cottonwood flume brings water to the plant. (Los Angeles Department Water and Power.)

The Los Angeles Aqueduct Project brought environmental destruction, loss of agriculture, loss of employment, and many other negative factors to Lone Pine. The project also required Los Angeles to build infrastructure, including railroad lines, much improved roads, and many new jobs. This is the Cottonwood Power Plant during construction; it is still working in 2007. (Los Angeles Department Water and Power.)

The beginning of the aqueduct here reflects the dream recorded in *Pictorial History of the Aqueduct*. "A drop of water, taken up from the ocean by a sunbeam, shall fall as a snowflake upon the mountain top . . . be borne along a weary way in darkness and silence . . . be taken up from beneath the ground by a thirsty rootlet and distilled into the perfume of an orange blossom in the City of the Queen of the Angels." (Los Angeles Department Water and Power.)

The city took a river and brought it to itself. The flowing Owens River that fed irrigation canals in the valley was captured, the riverbed left to dry out, and canals emptied. The Owens River flowed in 1907, and only began to flow again in 2007 after the LADWP was forced to put water back. (Los Angeles Department Water and Power.)

Two women dressed in black observe the very first well dug to help fill the aqueduct. In April 1913, Mulholland and a committee met with valley farmers and verbally agreed to the right of valley ditches for a specific flow from the Owens River. The agreement was never made binding and was never honored. (Bruce Branson collection.)

A Los Angeles dredge works constructing the aqueduct north of Lone Pine not far from Manzanar. Many different methods, from hand-operated shovels to steam and electric shovels, drills, and modern tunneling equipment, were used in construction that saw a maximum of 3,900 men employed during the period May 11 to May 20, 1910. (Bruce Branson collection.)

The list of requirements the LADWP needed to supply to complete the work included 53 work camps with 2,300 buildings and tent houses; a cement plant near Tehachapi called "Monolith;" 500 miles of roads and trails; and 400 miles of telephone and transmission lines. The Southern Pacific put in a 120-mile spur from Mojave to Owenyo near Lone Pine. The railroad had to cross the aqueduct near Olancha on a bridge. (Los Angeles Department of Water and Power.)

A certain beauty is seen in the curve of the canal walls on the way to Haiwee reservoir near where the Southern Pacific (SP) rail crossed the aqueduct. The SP line and the Carson and Colorado line, now owned by SP, met at Owenyo, where freight could be transferred to continue either north or south. (Los Angeles Department of Water and Power.)

Near Haiwee Meadows, where Mrs. McGuire and her six-year-old had become some of the last white victims of the Indian War, the LADWP built a reservoir. The Haiwee Reservoir was built seven miles south of Owens Lake, is located in a pass, and was formed by two dams 7.5 miles apart. (Los Angeles Department of Water and Power.)

The canal (pictured north of Haiwee) ran from the intake to the reservoir and was 60 miles long. Once leaving the reservoir through a tunnel 1,193 feet long and 10 feet in diameter, water flowed by gravity to the San Fernando Reservoir. Haiwee could hold water equal to 80 days of aqueduct flow. (Los Angeles Department of Water and Power.)

On October 13, 1913, water was first released into the canal at the intake. (Los Angeles Department of Water and Power.)

William Mulholland, Los Angeles city water superintendent and visionary civil engineer, stands strongly in a formal portrait out on location on the Los Angeles Aqueduct Project. At the official arrival of the water and ceremony celebrating completion of the project, Mulholland simply said, "There it is. Take it." (Los Angeles Department of Water and Power.)

When it became obvious that more water was needed for the aqueduct to quench the thirsty city, the department made plans to extend the system north to Mono Lake. Problems and frustrations multiplied in the valley. Turmoil and community anger finally boiled over when on Sunday, November 16, 1924, a group of 100 Owens Valley residents and ranchers, led by Mark Q. Watterson, seized a part of the aqueduct in Alabama Gates, a few miles north of Lone Pine, and released the water down the drain back toward the Owens River. Mulholland had mused on a trip to the Colorado River Region, "For myself, I should prefer to see Los Angeles get its water elsewhere. . . . This enterprise means more strife and fatigue in a life that has been filled with both." He refused to deal with the rebels or meet their demands. The event was a combination of violent protest and country picnic, and the *Los Angeles Times* took a stand against the unlawful behavior but noted in a story that "Camp at Aqueduct Gate is Center of Family Life." (Above, Eastern California Museum; below, *Los Angeles Times*.)

The event caught the attention of the media and symbolized the battle waging between the farmers and ranchers of the valley, who depended on the water, and the city, which did likewise. Gov. Friend W. Richardson refused to send troops, remarking it was strange that the aggressors (in Los Angeles) were asking for troops, while the injured party (Inyoites) asked for nothing. (Eastern California Museum.)

Tom Mix, who was filming *Riders of the Purple Sage* in Lone Pine, sent his orchestra to entertain during the troubles, but it wasn't a political statement but the gesture of a showman. The governor stated it should be settled in the courts but sent California state engineer W. S. McClure to investigate. (Eastern California Museum.)

W. W. Watterson appeared before the Los Angeles Clearing House Association to ask a commission be appointed to investigate. J. A. Graves, president of Farmers and Merchants Bank, agreed as long as the Owens Valley ranchers' claims be presented in writing. The rebels agreed, but before departing, they had one final barbecue to use up all the food they had collected for the siege. (Eastern California Museum.)

One observer remarked the "producers of the 'Battle of Lone Pine' have not yet announced when the next installment of their serial will be released." (Quoted by Catherine Mulholland on her book *William Mulholland: The Rise of Los Angeles*, about her grandfather.) On June 10, 1927, after more violence and dynamiting of the aqueduct, Los Angeles sent a whole trainload of guards with sawed-off shotguns to protect their water lifeline. (Los Angeles Department of Water and Power.)

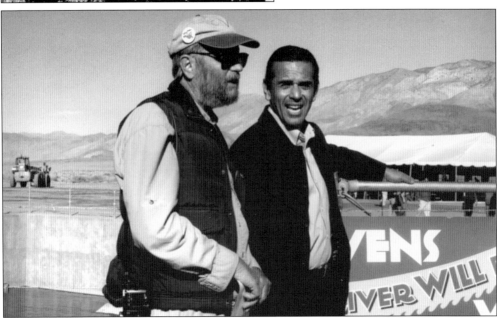

Trouble and violence have marked the fight over the Owens Valley water ever since. Since the 1970s, the fight has been a legal one made in courts. Most recently, the State Attorney General's office, Owens Valley Committee, and Sierra Club won in court. Los Angeles mayor Antonio Villaraigosa (right) looked thrilled when, in December 2006, the water was turned on while Lone Pine environmental activist Mike Prather (left) looked on. (Mike Prather collection.)

Five

TOILING FOR COMMERCE

Life was never easy in Lone Pine and the surrounding areas. After the Native American conflict was ended and ethnic cleansing completed, the settlers were free to develop ranching and agriculture, pursue mining, and set up the towns.

John Walton, in his book *Western Times and Water Wars*, shows that the population in Inyo County grew from just under 2,000 in 1870 to almost 4,400 in 1900. Farms almost doubled in the 20 years; in 1880, there were just 242, and by 1900, there were 424. The area around Lone Pine was not quite as heavily agricultural (compared to northern Inyo and Bishop) because of a shortage of water. The years of boom for Cerro Gordo were over before 1880, and other mining areas came and went from boom to bust.

Walton notes that 4 percent of the general population was listed as professional in the Great Registry of 1908; 41 percent farm and ranch; and 25 percent skilled trades and mining. Clerical and service made up 11 percent of the male population of voting age, while 14 percent were categorized as labor. Since women did not have the vote, and thus were not covered in these statistics, Walton notes, "Their exclusion from the enumeration produces some bias in the occupational structure." From 1908 to 1922, little had really changed in the percentages in each category of jobs, although professional had risen from four to seven percent; clerical had risen slightly, ranching dropped, and mining dropped by six percent.

The water wars continued to take their toll in agriculture, the environment, and jobs. The LADWP began to bring jobs to the area, however. Lone Pine began to exploit its natural environment—the mountains, the deserts, fishing, and hunting—realizing this would provide a revenue stream, although with unpredictable variations. The new road to Death Valley opened in 1937 with a promotion dubbed "the wedding of the Waters." The Lone Pine Chamber of Commerce organized and businesses increased. Main Street stretched to several solid blocks.

Tourism increased as people began to travel. However, tourism is affected by the state of the general economy, so some years were busy years; other times, the visitors and their dollars evaporated. Periodically there were jumps in mining, but these were never permanent.

A gorgeous group of rainbow trout glistens in the mountain sunlight next to this lucky fisherman's creel. Lone Pine learned to promote its excellent stream and mountain lake fishing, focusing on its rare golden trout. (Beverly and Jim Rogers Museum of Lone Pine Film History.)

In the 1890s, the Fourth of July was a time to celebrate the country's birthday and to show off new finery. Families promenade up and down the street before going to the plaza for the official celebrations. The heat would have been pronounced, and the women carry parasols to protect themselves from the intense sun of the desert. (Bruce Branson collection.)

Lone Pine's Main Street is hardly bustling in this 1912 picture. That empty street was Highway 6 (now labeled 395). Ranchers and the few farmers left were probably talking of the Los Angeles Aqueduct that was nearing completion and would change forever the face of the land around Lone Pine and the town's primarily agricultural economy. (Bruce Branson collection.)

Silas Christofferson set a world's altitude record flying several hundred feet above the peak of Mount Whitney on Wednesday, July 24, 1914. The feat had been preceded by several days of aeroplane flights. The admission in Bishop was $1. The program also listed boys' kite flying, a brass band, balloons, races, and baseball between the Bishop White Team and the Bishop Native American team. (Bruce Branson collection.)

The printed Aviation Program also announced Christofferson's flight of 70 miles along the Exposition Way, over Big Pine and Independence to Lone Pine. The next day, the pilot would make "preparations for the greatest flight the world has ever known, right here in our little valley." The era of aviation had arrived in Lone Pine. (Bruce Branson collection.)

Adventurous tourists set out for Lone Pine and Death Valley in the early 1920s. Four tourists pose with their touring car in front of Mount Whitney, obscured in this photograph by ambient dust, to prove to their friends they arrived safely. Few tourist amenities had opened yet, but the newly opened Dow Hotel (1923) provided excellent accommodations for the traveler. (Bruce Branson collection.)

In many ways a quiet small town, Lone Pine had one major difference. Highway 395, an important West Coast north-south thoroughfare going directly through town, assuaged Lone Pine's remote location. Cars became a common sight on the still-unpaved street, as this early photograph shows. Tourism was to become a major industry for the town. (Bruce Branson collection.)

Members of the Inyo Good Roads club pause in Lone Pine. The members of the club, organized in Bishop about 1913, never missed a chance to demonstrate the value of having a good road system for the Lone Pine and Owens Valley area. Flags decorate the cars to attract the attention of residents and the early media for the campaign as the caravan travels by. (Bruce Branson collection.)

When the movies discovered the unique locations around Lone Pine in 1920, Hollywood started traveling to the remote area on a regular basis. With only limited accommodations, Walter Dow realized a new market was evolving, and he built the Dow Hotel, which opened in 1923. Such notables as Tom Mix, John Wayne, and Roy Rogers all stayed there more than once while filming. (Bruce Branson collection.)

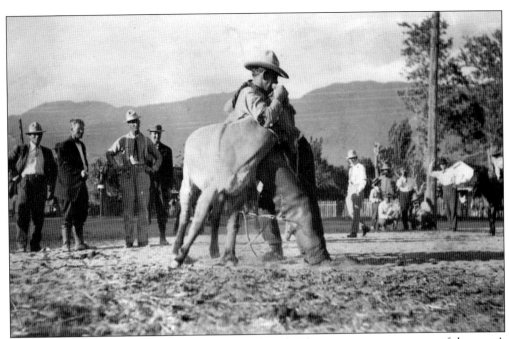

From the beginning of Lone Pine's history, ranching has been a major component of the town's economy. Rodeos provided one of the best outlets for recreation for all the cowboys who worked the ranches. Many events were staged for the movies as well. Here a cowboy wrestles a steer in the 1930s as onlookers cheer him on. (Bruce Branson collection.)

George Brown, early settler in the Olancha area, sits astride his horse. Ranching remained a major economic factor in the local economy, even though it became a more challenging endeavor after control of water was wrested away from local landowners. Brown's ancestors included the Walker family, Alonzo Brown, and Sheriff Thomas Passmore, who was killed in the line of duty in Lone Pine on February 10, 1878. (Lenis Munis collection.)

The Carrsaco family name is one that is heard frequently in discussions about the history of Lone Pine. Cris Carrsaco, born in 1868 and pictured about 1900, came here when his father found work at Cerro Gordo. As a child, he knew Charles Begole, who laid out the town of Lone Pine. He played beneath the original lone pine before it was undermined by the creek and felled in a windstorm. Among many occupations, he served as Inyo County coroner for many terms. (Lone Pine AARP.)

Many Lone Pine pioneers led interesting lives and worked long hours seven days a week to build the community that exists today, Among these men were Frank Chrysler (left), seen with Russ Spainhower (center) and an unidentified friend. Frank Chrysler worked in the mines, built the salt tram, and eventually had his own pack outfit, which he sold to Livermore. He was a range rider for various cattlemen and served as town trustee, overseeing the rodeo grounds, town hall, and baseball fields near the Film History Museum. (Joy Anderson collection.)

Inyo County, California —the Inland Empire

AN INYO COUNTY HERD *Photo by Forbes*

Homes for Homeseekers

The above herd was raised and fattened on Inyo County meadows. There are few regions anywhere that can equal the grassy plains and mountain meadows of this county for pasturage.

A bunch of 47 Inyo County young draft horses recently sold at an average price of $225 a head for Los Angeles markets.

Thousands of dollars are made each year by turning cattle into mountain meadows in the Summer, and returning them to the valleys in the Fall, ready for shipment to the market. These pastures can now be secured by application and paying a small rental fee to the Government, and a large capital is NOT necessary to get a start. Look into the stock raising possibilities of Inyo County before investing. Ordinarily the dairy herd will offset current expenses, but you are not compelled to depend on your herd entirely, as all the fruits and vegetables are raised in abundance.

Unimproved agricultural lands for $10 and up—improved tracts for $50 per acre and up.

Inyo County honey is not surpassed anywhere, and was awarded the Gold Medal at the Lewis and Clark Exposition, Portland, 1905.

For further information, address

BOARD OF SUPERVISORS, INYO COUNTY, *Independence, California,* **U. S. LAND OFFICE,** *Independence, California or* **CHAMBER OF COMMERCE,** *Bishop, California*

"Homes for Homesteaders" were advertised by the Inyo County supervisors. They cited the "herds raised and fattened, draft horses that sold for $225 a piece, turning cattle into mountain meadows," and "Inyo County honey . . . awarded the Gold medal at the Lewis and Clark Exposition, Portland 1905." Unimproved agricultural land went for $10, improved land for $50 per acre. (Lenis Munis collection.)

The new Lone Pine Elementary School on the site of the present Lo-Inyo School had separate boys' and girls' playgrounds according to Relles Amick (Carrsaco). The town celebrated Christmas there on the second floor with a giant community Christmas tree at each end of the room. (Bruce Branson collection.)

The Oasis was an early stopping place in Olancha, as people began to understand that tourism and hunting were marketable commodities. The sign states, "For Sportsmen . . . for Travelers." (Lenis Munis collection.)

Main Street in Lone Pine went through many changes over the years. There were fewer trees, and more businesses served locals and the brave travelers who began to explore the mountains and Death Valley. One of the pharmacies can be seen on the west side, with the Sprouse-Reitz store in the next block. (Bruce Branson collection.)

Another view of Main Street shows the Santa Rosa Catholic Church on the right or east side before it was moved to its present location on Locust Street. The Dow Hotel had doubled in size and was serving the filming companies and visitors who were bringing a new kind of commerce to the town. (Bruce Branson collection.)

The Owens River had plenty of water in it still in this picture that shows the bridge crossing it by Lone Pine. Some of the pilings can still be found in the newly rewatered streambed. (Bruce Branson collection.)

Lone Pine could have been nicknamed the "town of wandering churches." The Santa Rosa Catholic Church seen on Main Street was moved to Locust Street. The Trinity Episcopal Church was also on Main on the west side and was relocated where Locust turns south to become Lakeview Street. (Bruce Branson collection.)

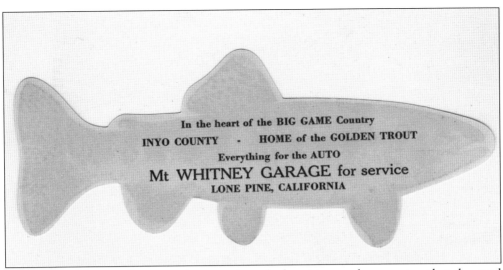

The Mount Whitney Garage, in its trout-shaped advertising card, recognizes that the good fishing—goldens, rainbow, and natives—is worth advertising. If you need automobile repair "In the heart of the BIG GAME country," apparently Mount Whitney Garage is the place. (Bruce Branson collection.)

Lone Pine Depot was constructed by John Worthington of Oakland, California, for $5,400. It was finished and open for service on June 1911. Private renters live there now. Some internees on their way to Manzanar carved their names into the wall while they waited for transport. (Bruce Branson collection.)

The Slim Princess pulls into the Keeler Station after the great mining era has ended. Eventually Southern Pacific purchased the Colorado and Carson Railroad, operators of the narrow gauge. The last narrow-gauge Slim Princess run was in 1960. The California Highway system, beginning after 1900, became the backbone of the transportation system. (Chris Langley collection.)

A barbecue celebration of the opening of the road to Death Valley was called "The Wedding of the Waters" by Father Crowley, the Catholic priest who worked tirelessly for the souls and commerce of the area. Deep-pit barbecue remains a community tradition still. (Bruce Branson collection.)

$25 Reward

For Information leading to the recovery of the following:

These watches, 68 finger rings and 12 bracelets were stolen from P. J. Bauer's store at Lone Pine, Cal., Sept. 10th, 1912.

Size 18 Htg. Case No. 4744128 Gold Filled Movt. No. 5138439 Ny. Sta.
" 18 O. F. " " 8261428 " " " " 13552397 Adj. Elg.
" 18 O. F. " " 8295290 " " " " 2660317 Dwoo. Ham.
" 18 O. F. " " 8026075 " " " " 14957050 Elg.
" 18 O. F. " " 9178816 " " " " 2526820 Hum.
" 18 O. F. " " 7410997 " " " " 14952376 Wal.
" 16 HTG " " 7633022 " " " " 2302394 Gen Stark Ham.
" 16 HTG " " 8222396 " " " " 15774671 Elg.
" 16 O. F. " " 8230503 " " " " 2712972 Adj. Ham.
" 12 HTG " " 7946573 " " " " 12192990 Adj. Elg.
" 12 HTG " " 7835151 " " " " 2280489 Drieb Gr. Ham.
" 12 HTG " " 7144233 " " " " 2284651 Ham.
" 12 HTG " " 8078281 " " " " 16103853 Elg.
" 12 HTG " " 8156459 " " " " 4691799 Ny. Sta.
" 12 HTG " " 4811255 " " " " 4915542 Ny. Sta.
" 12 O. F. " " 6490604 " " " " 15612727 Elg.
" 12 O. F. " " 4919769 " " " " 2134520 Ham.
" 6 HTG " " 7946515 " " " " 15373775 Elg.
" 6 HTG " " 7652357 " " " " 16861105 Wal.
" 6 HTG " " 7442634 " " " " 14207262 Elg.
" 6 HTG " " 263737 Inlaid Gun Metal " 14710162 Wal.
" 6 HTG " " 4895996 Gold Filled Mov. " 4925038 Ny. Sta.
" 6 HTG " " 4654750 " " " 4858263 Ny. Sta.
" 0 HTG " " 951915 Silver filled, gold inlaid flowers
Movt. 202133 Suffolk.
" 00 Gold Dec Dueb 7780046 Gold Filled " 2739493 Ham.
" 00 HTG Case 7770172 " " " 2636818 Adj. Ham.

Wanted for Burglery

Mexican, 28 or 30 years old, height about 5 feet 10 inches, weight about 155 pounds, slight build, black hair, small black mustache, wore a smoky grey suit, soft light felt hat, wore No. 6 shoes.

I hold Felony Warrant. Wire information at my expense.

CHAS. A. COLLINS, Sheriff Inyo County, or

D. M. NICOLL, Constable, Lone Pine, Cal,

The town was born in lawlessness, as the legend of "a murder a day for three years" at Cerro Gordo in the 1870s became well known. Famous California bandit Tiburcio Vasquez hung out at Coyote Holes with his cutthroats in 1874. A wanted poster dated September 10, 1912, offers a $25 reward for a Mexican wanted for burglery [sic]. Sheriff Collins apparently did not have Lone Pine constable D. M. Nicoll proofread the poster. (Bruce Branson collection.)

Owenyo was the town where the narrow-gauge and the broad-gauge systems, both owned by Southern Pacific, could transfer freight. Owenyo was a town of its own, and some Lone Pine residents were born there before moving to town. All this ended in 1960, when the railroad closed and the town was torn down. (Lenis Munis collection.)

Thanks to the LADWP's work, Lone Pine had electricity generated from hydroelectric power. The Southern Sierra Power substation was located out by the railroad tracks not too far from the present-day Lone Pine dump. (Lenis Munis collection.)

Many Lone Pine and Olancha residents spoke glowingly of their trips to the backcountry of Monache Meadows, Templeton Meadows, and Mulkey Meadows. The summer range was there, meaning an escape from the heat of the valley and a very good life. A cattle round up is going on in Monache Meadows in this picture. (Lenis Munis collection.)

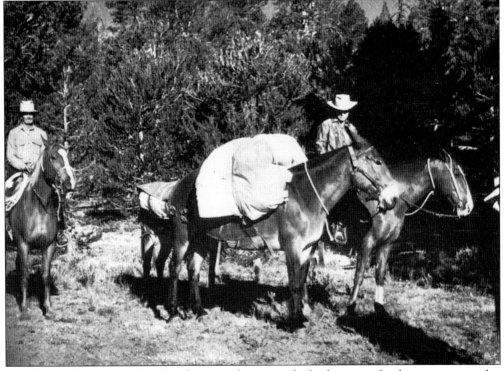

John Lacey of the Lacey Ranch is shown packing into the backcountry for the summer months, carrying supplies covered by a large tarp. (Lenis Munis collection.)

Part of George Brown's herd stands before the Sierra Nevada in an Olancha pasture. The Hunter family spread would drive the cattle south and east to Hunter Mountain for winter forage. (Lenis Munis collection.)

A much earlier picture shows Anton's Resort in the mountains. It advertised itself as the only such resort in the high country for tourists, an early example of local residents discovering the appeal of their lifestyle to the visitor. Today's Western lifestyle has become an important cultural-heritage tourist business. (Lenis Munis collection.)

Six

The Shoot 'Em Ups Take Control

In the Olde Lone Pine Hotel, Roscoe "Fatty" Arbuckle, a superstar of the early silent films, stretched and rose to go out on location. It was January 1920. He was at work on his feature film, a story of an overweight sheriff, loneliness, love, and bandits. Based on a popular play after 1900, it was a major change for the comedic star noted for his acrobatic stunts. Just over a year later, his career would be destroyed by a scandal.

Filming had come to Lone Pine. Through the present day, feature filming would return to the area nearly 400 times, with countless commercials, documentaries, and television shows. In addition, so popular did the location of Lone Pine and its environs prove to be that by the fall of 1920, a new company was on location, staying in tents because of the lack of enough rooms in town.

By 1923, Walter Dow had built his hotel to accommodate the industry that would make the area familiar to Western film fans around the world. What brought Arbuckle to the new location 200 miles north of Los Angeles is not clear. Director Clarence Badger had discovered Lone Pine in 1917 and bought property there. He would eventually build a fishing and hunting lodge on the banks of Lone Pine Creek. He had worked at the Keystone studios with Arbuckle, although he never directed him. He probably told Arbuckle about the beautiful and very scenic area.

Lone Pine was perfect for these film companies. There was plenty of sunshine. The mountains were magnificent. The Alabama Hills provided wonderful backdrop for Western action. With other high desert locations nearby, the locations were varied and accommodations were very close. The adage of film, still valid today, stated, "Time is money." With the Alabama "Rocks" just a few minutes away; it took a few minutes to be on set and working.

Soon there was the echo of gunfire nearly every day as the bad guys and the "white hats" shot it out. Of course, until the late 1920s, the sounds went unrecorded. The Westerns, nicknamed "Shoot 'em Ups," had taken the land by storm.

Lone Pine film contact Russ Spainhower (left) clowns with John Wayne on the set of *Tycoon* in the spring of 1947. The major set of a railroad tunnel construction site was supposed to be in the Andes Mountains of South America. The set was suspended from one outcropping of rocks to another near the Portal Road. Bolts and plaster can still be found in the rock. (Joy Anderson collection.)

Silent superstar Roscoe "Fatty" Arbuckle leans against a camera tripod awaiting his shot for Lone Pine's first film, *The Round-Up*, made almost entirely on location in January 1920. (Beverly and Jim Rogers Museum of Lone Pine Film History.)

Putting on his make-up for the final shoot-out in *The Round-Up*, Fatty Arbuckle made his first feature-length film in town and out in the Alabama Hills. Arbuckle was a famous comedian at the time, filming his first dramatics role as Sheriff "Slim" Hoover. Within a year and a half, however, his career would be destroyed by a scandal involving the death of a young woman at a party of his. (Beverly and Jim Rogers Museum of Lone Pine Film History.)

Buck Jones would have a long career, from silents to sound films, appearing several times in Lone Pine. Above, the William Fox Film Company works filming Jones's Western *Durand of the Badlands* in 1925. Below is a still from the film showing Jones in the Alabamas with his horse, Silver. (Both images Chris Langley collection.)

Tom Mix sits with his love (played by Beatrice Burnham) and her daughter (Mabel Ballin) near the Sierra Nevadas in the finale to Zane Grey's *Riders of the Purple Sage* (1925). Tom Mix was working in a film in Lone Pine for the second time, having made *Just Tony* in 1922 there. At the time of *Riders*, Mix was a superstar rivaled only by the popularity of his horse, Tony. (Beverly and Jim Rogers Museum of Lone Pine Film History.)

In an ironic twist, Mix shot the horse rustler only to find a woman. In this image, Mix and Tony guard her while she recuperates from the wounding. The location is only 100 feet from where the set from *Tycoon* was located in Ruiz Hill. The same area was very popular with Robert Mitchum, who worked there in *Nevada* (1944), and Gene Autry in *Cow Town* (1950). (Beverly and Jim Rogers Museum of Lone Pine Film History.)

Jack Hoxie looks out across the Alabama Hills at a gang of riders in the film *Back Trail* (1924). Hoxie, along with brother Al, for several years was a regular in Lone Pine, making more than 12 films in the area. He was well known by townspeople, and at one point, he participated in a Thanksgiving turkey shoot with other Lone Piners. (Beverly and Jim Rogers Museum of Lone Pine Film History.)

Fred Humes (left) was a popular silent-film cowboy star. Here he is in *Arizona Cyclone* (1927) standing on what was once the "Old Place," the original Anchor Ranch–Spainhower lease where filming began. It is located behind the Film History Museum down Hopalong Cassidy Lane. It is now a private LADWP lease. (Beverly and Jim Rogers Museum of Lone Pine Film History.)

Often B Western budgets did not include much for sets, so houses around town were used. Here Hoot Gibson, nicknamed "Hooter," reaches up to female lead Mahaffey in the silent film *The Silent Rider* (1927). Gibson was a familiar figure in Lone Pine, famous for flying his own plane up to the location when he was working. Stories around town about his visits show he was well liked by locals. (Chris Langley collection.)

Singing cowboys Gene Autry, Roy Rogers, and Tex Ritter made many appearances in Lone Pine movies. There were also "cowboys who sing," who sang in pictures but were not known for the quality of their voices. Here Ken Maynard is shown in *The Wagon Master* (1929), marking the first time sound was recorded in a film in Lone Pine and the first time a cowboy singing was captured in a sound film. (Chris Langley collection.)

Shooting on location outdoors presented many challenges for early sound technicians. The equipment was bulky as the microphone appears here in Roy Roger's first starring role, *Under Western Stars*, made in the Alabama Hills in 1938. The film established Rogers, whose real name was Leonard Slye. He attained star status and became the King of the Cowboys. (Beverly and Jim Rogers Museum of Lone Pine Film History.)

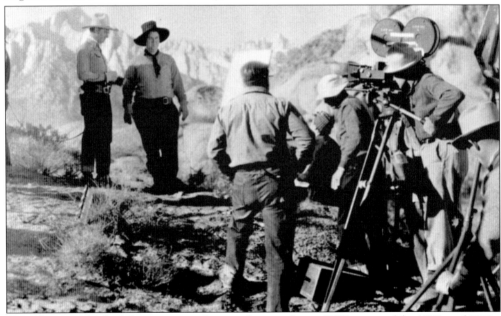

Gene Autry established the singing cowboy as a fixture of many B Westerns of the 1930s and 1940s. His singing voice and records (including his concerts around the country) established his very successful financial empire. He appears here before the cameras with his famous singing sidekick Smiley "Bullfrog" Burnette in *The Old Barn Dance* (1938) with Lone Pine Peak in the background. (Beverly and Jim Rogers Museum of Lone Pine Film History.)

When RKO Studios came to the hills the summer of 1938 to work on *Gunga Din*, Lone Pine's largest production, they did not have a fully completed script. Each night the stars and the director would sit around in the cooling air, drink beer, and plan the next day's work. From left to right in the foreground are four important people on the production: Sam Jaffe as Gunga Din, Douglas Fairbanks Jr., director George Stevens, and Cary Grant. (Chris Langley collection.)

Gunga Din is considered by Dave Holland, the Lone Pine Film Festival founder and film historian, as the town's "hallmark film." At its peak, there were more than 1,000 people, cast, and crew living in the tent city that was constructed on Movie Road. So large was the temporary town that it had its own post office and newspaper, and 15,000 pounds of ice was shipped from Los Angeles each week for the inhabitants. (Chris Langley collection.)

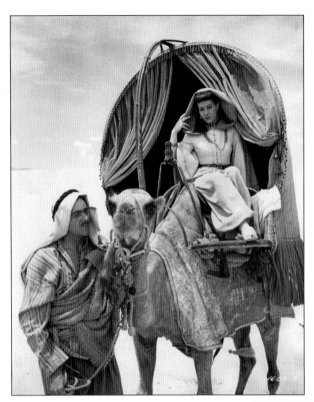

Besides all the Westerns made around Lone Pine, what are jokingly referred to as "Easterns" were also made. These were films set in India, Asia, and the Middle East, but in many ways, these films had action plots like the Westerns. *The Charge of the Light Brigade* (1936) was first to use the picturesque landscapes for the Khyber Pass and Himalayan Mountains. Here Maureen O'Hara rides on the Olancha sand dunes in *Bagdad* (1949). (Beverly and Jim Rogers Museum of Lone Pine Film History.)

Errol Flynn poses romantically for a portrait from *The Charge of the Light Brigade*. Other Easterns include *Lives of the Bengal Lancer* (1935) with Gary Cooper, *Gunga Din*, *King of the Khyber Rifles* (1955) with Tyrone Power, *Storm Over Bengal* (1937), *Oil for the Lamps of China* (1935), and even a Hopalong Cassidy feature called *Outlaws of the Desert* (1948). (Beverly and Jim Rogers Museum of Lone Pine Film History.)

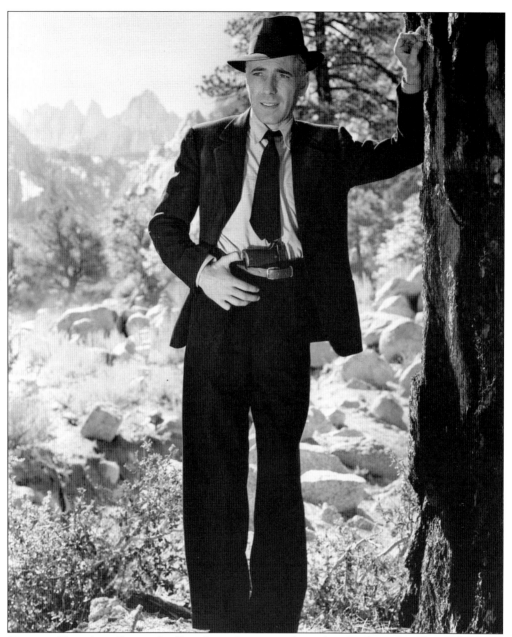

Gangster Humphrey Bogart finally achieved superstardom when he drove his Plymouth Coupe up Whitney Portal Road as Roy "Mad Dog" Earle in Raoul Walsh's classic *High Sierra* (1942). Established star Ida Lupino got top billing over Bogart but never again. Lupino would come back to direct her film *The Hitch-Hiker* (1955) in Lone Pine as one of the few female directors working at that time. The Whitney Portal Road that appears in the film is quite different from the one used today. *High Sierra* was remade in Lone Pine in 1955 as *I Died a Thousand Times* starring Jack Palance and Shelley Winters. For *High Sierra*, stuntman Buster Wiles created the famous sliding fall of Earle and nearly lost his life, missing the first two of three safety stops on the rocks. The place that Walsh staged the death scene can still be found at the Portals. Just ask at the Portal Store for directions. (Beverly and Jim Rogers Museum of Lone Pine Film History.)

In the 1950s, women began to move out from just being set decoration or victims to be saved. No matter how much trouble the female star had out in the dust and dirt, her hair always stayed perfect thanks to the on-set hairdressers. Two Tim Holt movies made locally illustrate this phenomenon. (Beverly and Jim Rogers Museum of Lone Pine Film History.)

In *Western Heritage* (1948), a Zane Grey story, Holt wrestles with Nan Leslie on Anchor Ranch pastures. This physical confrontation between hero and damsel was rare, even in the 1950s. (Beverly and Jim Rogers Museum of Lone Pine Film History.)

Ra Hould (standing), with Gene Autry (center) and Smiley Burnette on horses, are seen in *Boots and Saddles* (1938) near the rock named after Autry. (Beverly and Jim Rogers Museum of Lone Pine Film History.)

Time and again the same location was used by different directors. Popular was Gene Autry Rock, so named because of the picture above. Here the team called "the Three Mesquiteers," (from left to right) Max Terhune, Bob Livingston, and Crash Corrigan, are held at bay by youthful Sammy McKim in *Gunsmoke Ranch* (1937) at the base of Autry Rock. The rock was also used in *Brigham Young* (1940), *Bengal Lancer* (1935), and the serial *Jungle Raiders* (1944). (Chris Langley collection.)

Kirk Douglas made his first Western in Lone Pine in 1951 with *Along the Great Divide*. Here he manhandles Virginia Mayo, much to his pleasure and her frustration. This film had a wonderful cast, including three-time Oscar winner Walter Brennan and John Agar. Virginia Mayo returned to Lone Pine before her death as a guest of the local film festival in 1993. Walter Brennan starred in the classic 1955 film *Bad Day at Black Rock* along with Spencer Tracy, Anne Francis, and villains Lee Marvin, Ernest Borgnine, and Robert Ryan. Of the nearly 400 feature films that have shot scenes in and around Lone Pine, nearly 80 percent are Westerns. *Along the Great Divide* remains a good Western for modern audiences to watch today. (Chris Langley collection.)

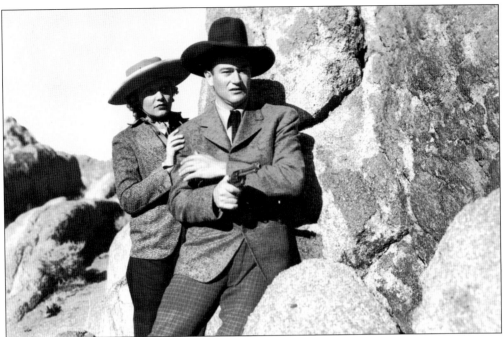

John Wayne worked in Lone Pine 12 different times, including his very last appearance before a camera for a Great Western Bank commercial. Here he appears in an early B Western entitled *King of the Pecos* (1936). With the commercial failure of *The Big Trail*, Wayne returned to low-budget B Westerns and shot several in Lone Pine, including the first Republic Studios Western, *Westward Ho* (1935). (Chris Langley collection.)

A wet John Wayne sits with a blanket wrapped around him while director Henry Hathaway keeps him company on the set for *North to Alaska* (1960). The set was located up near the CCC Camp off of the Portal Road and involved a fight between Wayne and costar Stewart Granger down a muddy slope at a mining claim with a water sluice pouring water on them. Through much of his career, Wayne enjoyed doing his own stunts whenever possible. (Beverly and Jim Rogers Museum of Lone Pine Film History.)

Perhaps one wouldn't expect Tarzan where so many Westerns were made, but two different Tarzans (Lex Barker and Johnny Weissmuller) worked in Lone Pine. Lex Barker worked in Lone Pine in *Tarzan's Savage Fury* in 1952. Old timers remember cheering at the Mount Whitney Theater on Main Street as the camera panned up to the tallest mountain in Africa, which turned out to be Mount Whitney. Tarzan's group had to scale it, and had done so before the last reel. (Chris Langley collection.)

Johnny Weissmuller had already been to Lone Pine for *Tarzan's Desert Mystery* (1942), which features Nazis, a man-eating plant, and a giant spider. Tarzan and Boy (Johnny Sheffield) worked on the sand dunes of Arabia, impersonated by none other than the Olancha Dunes. Weissmuller would return to Lone Pine a few years later to inaugurate the Memorial Plunge, the new town pool. (Chris Langley collection.)

Some stars were just working people, and Randolph Scott, who made 12 films during his career locally, was an everyday Joe. Locals say he would come in off the set in his costume, dirty and tired, just like them after a day of work, eat dinner at a local café, and then go off to his motel room to shower. For *The Tall T* (1957), he relaxes with costar Maureen Sullivan, holding a parasol, while to the left sits director Budd Boetticher. (Chris Langley collection.)

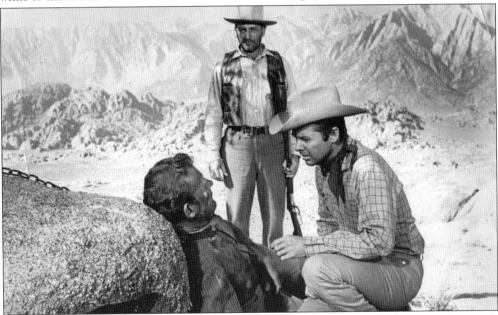

Sometimes Western stars come directly off the ranch, sometimes from a background of romantic comedy and sometimes serials. Audie Murphy, seen with Oliver Drake in *Showdown* (1962), came from the battlefields of World War II, having achieved the honor of being the most decorated soldier of that conflict. He made three of his best Westerns in Lone Pine before his life was cut short by a plane crash. (Chris Langley collection.)

It was early in his career when Gregory Peck came to Lone Pine to make *Yellow Sky* (1948), directed by William A. Wellman. The film is a classic study of a bad man going straight for the love of a good woman, and watching Ann Baxter win Peck is worth the price of admission. Like other Lone Pine films, the unit also worked in Death Valley. Peck returned to the area to make *The Gunfighter* (1950) and *How the West Was Won* (1965), as well as a guest appearance at the 1995 Lone Pine Film Festival. (Beverly and Jim Rogers Museum of Lone Pine Film History.)

Nevada Smith starred Steve McQueen, pictured in the Alabama Hills. It filmed out at Dolomite, up at Cerro Gordo, at Laws outside Bishop, and up near Mammoth. Loren Janes was McQueen's stunt double in that film and worked here in several other films, including *Thunder in the Sun* (1959) and *How the West Was Won*. Janes is on the Film Museum Board and has appeared at all of the film festivals since they began. (Beverly and Jim Rogers Museum of Lone Pine Film History.)

Clint Eastwood made parts of *Joe Kidd* (1972) in and around the Alabama Hills as well as north in the county by Bishop. Also starring Robert Duvall and Karl Malden, the film is one of the many Westerns Eastwood made at the height of his early career. Throughout the span of the Western genre, almost every cowboy star worked in Lone Pine, often more than once. (Beverly and Jim Rogers Museum of Lone Pine Film History.)

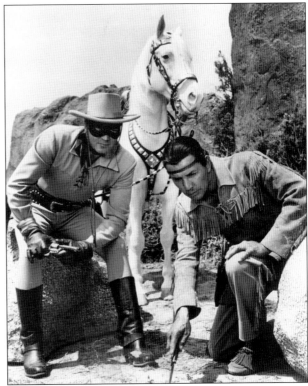

Fictional characters long associated with Lone Pine, the Lone Ranger and Tonto—Clayton Moore (left) and Jay Silverheels—study the tracks and plan what to do next. The Lone Ranger character made his first appearance before the cameras in Lone Pine in 1938, when director William Witney and his partner John English created the serial *The Lone Ranger*, also released in a feature format as *Hi Yo Silver* (1940). (Beverly and Jim Rogers Museum of Lone Pine Film History.)

Two mavericks share notes on the set of the film *Maverick* (1994), which worked in Lone Pine and surrounding areas. Mel Gibson and television Maverick James Garner speak on the dry lakes east of town. Gibson was often seen working with director Richard Donner, learning the trade of directing. Soon after, Gibson directed *Braveheart* (not filmed in Lone Pine), earning himself an Oscar. (Chris Langley collection.)

A large crew and actors carefully scramble over the famous rocks in a scene from *Maverick*. Managed by the Bureau of Land Management, the area is used frequently by film crews who are constantly reminded "Don't Crush the Brush," a public relations campaign in partnership with the Inyo Film Commission and Lone Pine community to keep the area clean and undamaged in what is termed a "semi-primitive" condition. (Beverly and Jim Rogers Museum of Lone Pine Film History.)

Lone Pine has played many areas around the world and around the galaxy for Hollywood. Besides Asia, South America, Afghanistan, and Africa, it has also been used for the planet Nimbus IV (*Star Trek 5: The Final Frontier*, 1989) and Krypton, Superman's home planet (*Superman* serial, 1948). In the serial *Brick Bradford* (1947), the main characters confer on the surface of the moon. Dinosaurs, sand worms, and cyber soldiers have also stamped across this landscape for directors. (Chris Langley collection.)

A flying saucer hovers over the Anchor Ranch, where the famous Hopalong Cassidy set and Western street was turned into a mission in China for its last appearance on film in *Bamboo Saucer* (1967) starring Dan Duryea, Lois Nettleton, and John Ericson. Best termed a cult classic, the film can be caught occasionally on late-night television. (Chris Langley collection.)

As Westerns faded from the screen, film companies kept coming to the area to make other genres of film. Science fiction and horror grew in popularity, and soon there were giant mysterious sand worms under the earth reaching up to grab and eat the unsuspecting. *Tremors* (1990) balanced seriousness and respectful comic imitation of the 1950s science fiction films. Starring Kevin Bacon, Fred Ward, Reba MacIntyre, and Michael Gross, the film spawned a series. One of the Universal Studios graboid creatures can be seen in the Lone Pine Film History Museum. (Chris Langley collection.)

Many actors begin their careers in obscurity and go on to become big stars. Brad Pitt and David Duchovny worked in Darwin and stayed in Lone Pine for a film early in their careers called *Kalifornia* (1993) about a psychopath very believably played by Pitt. (Chris Langley collection.)

Russ Spainhower realized that a permanent set would have economic attraction for the movie companies. When the *Gunga Din* sets were dismantled, he bought lumber and materials and created the first such set, nicknamed the "Hacienda." Company art directors could change the set as needed with the understanding their upgrades became part of the property. The Hacienda became the Mission, seen on the Anchor Ranch location. (Joy Anderson collection.)

A full Western street was developed as part of the original set, but the movie business was beginning to subside in the area. The street was called "Anchorville," but was never used as much as originally conceived. The last film to work at the set was *Bamboo Saucer*, which converted the Mission into a Chinese mission with the addition of bamboo. (Joy Anderson collection.)

Lone Pine began to cash in on its long and diverse movie history in 1990 with the creation of the first Lone Pine Film Festival (called the Sierra Film Festival), with founders Dave Holland and Kerry Powell at the helm. The festival attracted the attention of philanthropist Jim Rogers, who got the idea of working with the townspeople to create a permanent film history museum. From left to right, Loren Janes, a fan, and William Wellman stand waiting for the parade. (Lone Pine Film Festival.)

The Beverly and Jim Rogers Museum of Lone Pine Film History opened its doors in 2006 and contains displays on many Western, science fiction, and Eastern heroes like *Gunga Din*. It also has an 84-seat movie theater and many expansion projects are in the planning stages. In this image, from left to right, Patti Doolittle, star Peggy Stewart, and artists Kerry Powell and John Knowlton stand in front of the museum mural. (Don Kelsen.)

Seven

LIVING IN AN
EPIC LANDSCAPE

Living in "a land worth fighting for" is only worthwhile if the quality of life is good. Life in Lone Pine through the last century was good, even when times were hard economically and few people really prospered. The land is truly epic in southern Inyo County, with the highest and lowest areas in the country separated by only 80 miles. People have had the gift of entertaining themselves in isolated areas. The people of Lone Pine did just that. Plays, dances, Chautauquas, fund-raising for community projects, visiting friends, and being with the family all filled the leisure hours for citizens.

While at times relations with the federal bureaucracy and Los Angeles could be tense, bordering on violent confrontation, the people never seemed to loose their sense of humor. A sign proudly posted in an Owens Valley restaurant stated "We don't give a damn how they do it in L.A." People joked about joining the Keeler Beach Yacht Club, and for many years the town had variety show called the Jabberwalk, where inevitably the Lions Club men dressed as women and performed a song in a chorus line.

For a while, one had to have been born in Lone Pine to be a "true" Lone Piner, but as the country's social structure changed, the changes trickled down locally. Charles Manson hung out in Southern Inyo, drugs appeared, and new economic challenges arose.

Lots of fun remained, if one enjoyed the outdoors. But the area might not be so enjoyed by those who prefer shopping at the mall. The town established the Lone Pine Stampede, and the rodeo was great fun and the competition serious. While outsiders wondered what there was to do in a small town in the middle of nowhere, the local residents wondered how they could find time for everything they really wanted to do.

People in Lone Pine live the good, American, small-town life that many city dwellers can only dream of having someday when they retire.

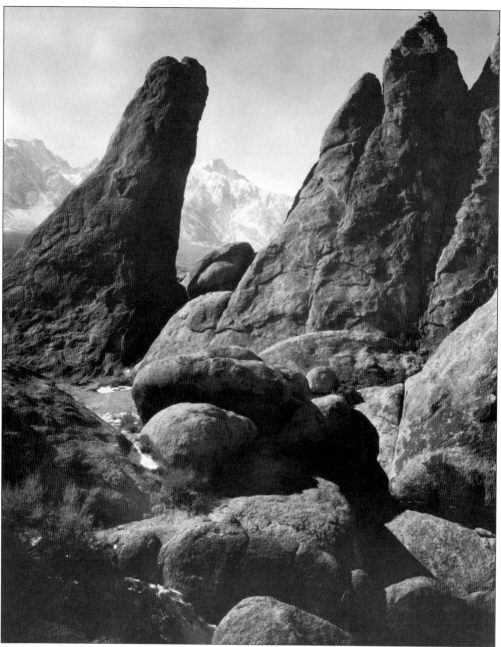

From the beginning, life in Lone Pine and the small satellite towns of Olancha, Keeler, Darwin, and Manzanar have been molded by the land. The stark beauty of the Alabama Rocks, the towering Sierra Nevada to the west, and the Inyos and Cosos to the east influence the life of the residents in many ways. Lone Piners know how to work hard, know how to have fun, and have never lost their sense of humor about themselves and the many challenges they face. That pioneering spirit still flourishes as the town enjoys itself while it fights for economic health in a changing world. (Beverly and Rogers Museum of Lone Pine Film History.)

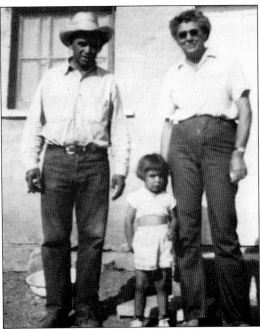

Life in the epic landscape is about families. Show are the Dearborn family and their sons, Luther (left) and Henry (center right). Next are Henry, Charlotte, and Ethel Olivas at Sage Flat. The Dearborn family came to Lone Pine in 1888, and Luther Henry Dearborn was involved in mining. Ethel married Ralph Ruiz and had Joe and Margaret (Terry). She divorced and married Henry Olivas, and they had Charlotte (Olsen). (Both images Lone Pine AARP.)

Some visitors notice that the pace of life in the area has its own rhythm and cannot be hurried. Perhaps that's because of the original, slower pace the pioneers had to accept. The Olancha freighter arrives in town with the mail in this early picture. (Lenis Munis collection.)

Two Olancha pioneers stand proudly, pausing from their ranching and home chores. From left to right are Alonzo Brown and Mark Lacey. John W. Lacey came to the area in 1873. John's great-grandson Mark carries on the cattle business today. (Lenis Munis collection.)

The Brown family has lived in Olancha and Lone Pine since 1877. This picture shows, from left to right, Annie Kimbler, Alonzo, George, mother Charlotte (Walker), and Laura. The pump faucet and handle in the Brown yard was used to water the teams coming from Cerro Gordo. The adobe house served as the post office and survived the earthquake of 1872 with one significant crack. (Lenis Munis collection.)

Fishing was a great pastime as an avocation or as a guide and has been a vocation for locals for the last 100 years or more. Here guide Frank Chrysler proudly displays a day's work on the rocks by one of the lakes in the high country. (Lenis Munis collection.)

Always ready to put the weather and the landscape to the work of having fun, locals love to go up to the snow, here tobogganing in front of Mount Whitney. Going up in elevation to enjoy the snow is a lot less work than having the snow come down and shoveling it. (Bruce Branson collection.)

An early postcard dated 1906 from Lone Pine shows Mount Whitney. The correspondent wrote, "This is the hill I am to climb next summer. It is only 15,000 ft. high." (Bruce Branson collection.)

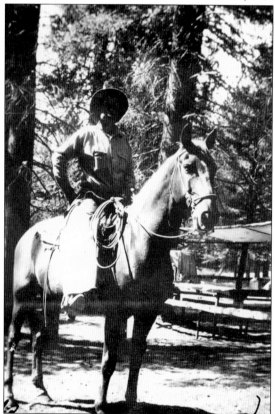

Old, portable cameras could capture the experience of being up in the backcountry for the summer while the cattle grazed. This image, and two on the next page, are from the Joy Spainhower (Anderson) album and are from Templeton. Russ Spainhower is on his horse in the thick of the woods. (Joy Anderson collection.)

Summer in the high country was a wonderful time for the kids, who would shack up in the tent cabins and learn practical equestrian riding techniques. (Joy Anderson collection.)

There was even time after chores for the girls to have a little fun. That's Templeton Peak in the background. (Joy Anderson collection.)

The 1864 Geologic Survey party included, from left to right, James T. Gardiner, Richard D. Cotter, William H. Brewer, and Clarence King. They surveyed and named Mount Whitney to honor Josiah D. Whitney, not on the survey. Later it was discovered they had mistaken Sheep Mountain (later named Mount Langley) for Whitney. The taller peak was actually a few miles north. King did not climb Whitney first. Three local men, including Charles Begole, did that on August 8, 1873, and they called it "Fisherman's Peak." After 1878, the original name of Mount Whitney was reinstated and attached to the correct peak. (Eastern California Museum.)

Felix Meysan signed a stock certificate for the Lone Pine Water Company. The water services, once supplied by the LADWP, were turned over to the individual towns. The County of Inyo oversees them. (Bruce Branson collection.)

Roy Hunter prepares dinner and coffee on the open cattle range, carrying on the cowboy traditions of his father, Bev, and his miner grandfather, William. Today Roy and Joy Hunter's son, John, carries on the cattle business, struggling against the ever more complex federal land regulations. (Lenis Munis collection.)

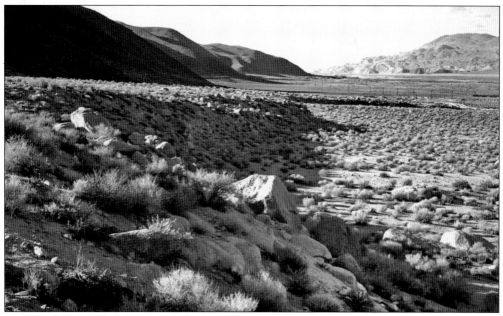

The people live with the active geologic conditions of the Owens Valley around Lone Pine. Here the fault line from 1872 is clearly marked by afternoon shadows and appears much as it did when the sun rose on that fateful morning of March 26, after El Temblor. (Chris Langley collection.)

The drudgery of mining was relieved by sports for a lot of the hard-working men. The Darwin baseball team appears in uniform and played other teams of the area, including those of Lone Pine. Adult softball remains a very popular pastime in the area. (Southern Inyo Museum.)

The Women's Card Club of Darwin is pictured. Many bridge, bunko, and canasta clubs have flourished through the years and still remain popular today. (Southern Inyo Museum.)

Actor Johnny Weissmuller (left) stands with Norman Kelly at the opening of the Lone Pine Memorial Plunge, built after Norman's brother Warren drowned in Diaz Lake. Weissmuller starred in a water show for the opening ceremonies that included clowns and diving exhibitions. (Rudy Henderson collection.)

Lone Pine businessman Rudy Henderson (right) and Patty Brierson stand in the doorway soon after the Memorial Plunge opened. Henderson was one of the driving forces behind the project, built through community efforts and fund-raising. He was out at Diaz Lake at the time of Warren Kelly's drowning. (Rudy Henderson collection.)

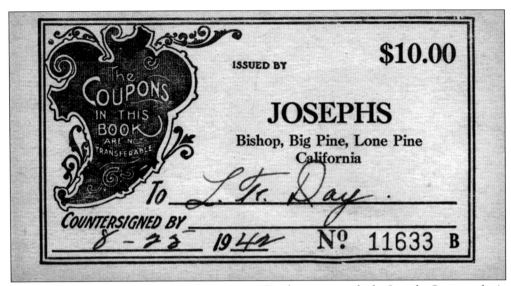

Food coupons with the Josephs Supermarket's name on it were available during the war years as part of the rationing program. This one booklet worth $10 was signed on August 25, 1942. (Both images Bruce Branson collection.)

In the old days, Diaz Lake and other bodies of water would freeze over to the point where cars could even be driven out onto the ice. That has not happened in many years. Here Lone Piners stand on the frozen surface of the aqueduct north of town with their skates laced. (Bruce Branson collection.)

Hunting remains a popular sport in the area. Jack Hopkins stands with an impressive specimen of the family *Cervidae*. Jack founded Hopkins Hardware (now Gardners) and served as county supervisor for the Lone Pine area. He was also involved in many civic projects including the building of the Mount Whitney Golf Club. (Beverly and Jim Rogers Museum of Lone Pine Film History.)

Several local ranchers sit admiring the rangeland of the area. From left to right are Frank Chrysler, movie star Roy Rogers, unidentified, and Russ Spainhower. (Joy Anderson collection.)

In this undated image, several waitresses and friends venture up to the set of the film *Gunga Din* to have their pictures taken on the suspension bridge, standing on the massive temple set, and playing with the props. Here Mildred Langston, in the cart, has her friends supply the power for the wagon from the film. (Mildred Langston collection.)

Variety shows and amateur talent extravaganzas were often held for entertainment and fund-raising for civic projects. One such show was called the Jabberwalk and was held annually for many years. The Lion's Club often resorted to cross-dressing to convulse the audiences, but that is a story for another time. (Lone Pine Chamber of Commerce.)

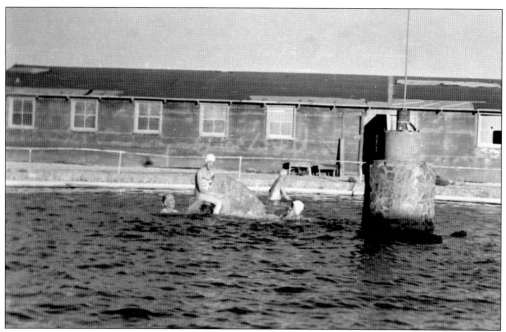

Dirty Socks, located on Highway 190, the Death Valley Road, was a fun place to swim in the 1950s. Named for the special smell of the water, the building is a barracks left over from the Manzanar Internment Camp after the war. Little of the glory remains today. (Lenis Munis collection.)

Life was good in Lone Pine, but the economy often struggled. In 1960, the Slim Princess made its last trip and was given to the Eastern California Museum. It is on display in Dehy Park in Independence. The town of Owenyo was doomed and was totally dismantled and taken away. Little remains today of the bustling railroad community. (Lenis Munis collection.)

The Lone Pine High School Band was directed by Dinty Moore, who achieved almost legendary respect among community music lovers. The high school auditorium has a very small plaque commemorating Moore. (Pete Aigner collection.)

Cowboy star Roy Rogers took time from a motion picture to meet the children at the Owenyo School. Russ Spainhower's wife, Catherine, seen with her arms around a girl, was the schoolteacher then. The picture was later autographed by Rogers, "Always my best to a cute bunch of boys & girls. Sincerely Roy Rogers." (Joy Anderson collection.)

Mining operations would occasionally surge, depending on the ore and the market, and then subside, and miners and the families would move from area to area. Here is a group of miners from the Darwin area posing for a picture. (Southern Inyo Museum.)

Bird hunting was a great pleasure in the crisp fall days. Several hunters pose with the birds they harvested that day. The hunting dogs look equally satisfied. (Bruce Branson collection.)

A couple fish by a creek in a very early photograph of the sport. They have several fish on the line to show for their work. (Bruce Branson collection.)

Lubken was another proud family name in Lone Pine, first coming to the area in 1862. John Lubken served as a county supervisor for 19 years, and the Lubken name has been preserved in different areas of the town. (Lone Pine AARP.)

Local residents in Lone Pine have always had many recreational choices if they enjoyed the great outdoors. Here a fisherman enjoys fly-fishing in one of the High Sierra's pristine lakes. (Eastern California Museum.)

Golden trout from the high country lakes are one of the rare, special attractions for the sportsmen in the area. Here a town barbecue celebrating the golden trout (served as the main course) is held in town during in the 1920s. (Eastern California Museum.)

Josephs Market replaced the original stores of the town, Meysan, E. H. Edwards's and Skinner, opening in Lone Pine after the store in Bishop was established. Here, in the 1950s, is the store at its present location. Nason Tobey owned the store and then sold it to the Williams family, who operate it now. (Lone Pine High School yearbook.)

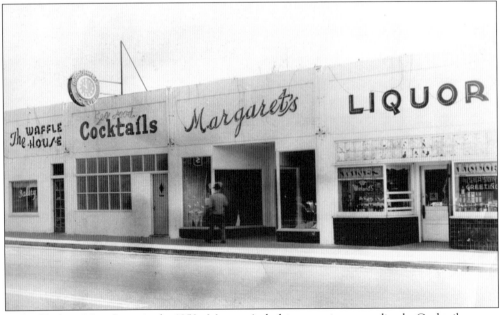

In this block on Main Street in the 1950s, Margaret's clothing store is surrounding by Cocktails on one side and a liquor store on the other, all owned by the same person. (Bruce Branson collection.)

A dress sale is underway inside the store in this undated image, with the prices of the dresses reduced to $3.95, $4.95, $7.95, and $14.95. Those prices have no doubt inspired the bargain hunters. (Bruce Branson collection.)

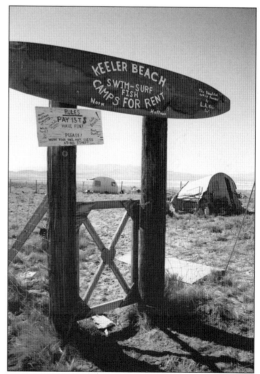

Keeler Beach is located on the shores of the Owens Dry Lake. Proprietor Norm Hoffman has set the rules: "Swim-Surf, Fish. Camps For rent. Rules: Pay 1st. Have fun. Wear your Haz. Mat. Suits at all times!" Local entrepreneurs will always search for opportunities to market the area to tourists, sportsmen (and women), and visitors alike. (Chris Langley collection.)

www.arcadiapublishing.com

Discover books about the town where you grew up, the cities where your friends and families live, the town where your parents met, or even that retirement spot you've been dreaming about. Our Web site provides history lovers with exclusive deals, advanced notification about new titles, e-mail alerts of author events, and much more.

MADE IN THE USA

Arcadia Publishing, the leading local history publisher in the United States, is committed to making history accessible and meaningful through publishing books that celebrate and preserve the heritage of America's people and places. Consistent with our mission to preserve history on a local level, this book was printed in South Carolina on American-made paper and manufactured entirely in the United States.

This book carries the accredited Forest Stewardship Council (FSC) label and is printed on 100 percent FSC-certified paper. Products carrying the FSC label are independently certified to assure consumers that they come from forests that are managed to meet the social, economic, and ecological needs of present and future generations.

FSC
Mixed Sources
Product group from well-managed forests and other controlled sources

Cert no. SW-COC-001530
www.fsc.org
© 1996 Forest Stewardship Council

Find Your Place in History.